COLORING OUTSIDE THE LINES

Applying Multiple Intelligences and Creativity in Learning

René Díaz-Lefebvre, Ph.D.

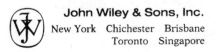
John Wiley & Sons, Inc.
New York Chichester Brisbane
Toronto Singapore

ISBN 0-471-48043-6

In Memory of Rudy J. Melone

My teacher, mentor, and dear friend. Thank you for encouraging me very early on to "color outside the lines."

CONTENTS

A Note From Howard Gardner

"A lively and readable introduction to the theory of multiple intelligences, with particular focus on college students. This book shows how a multiple intelligences approach can be used to teach concepts effectively."

PREFACE

This book was born out of the desire to share insights and experiences in my study, intrigue, and application of Howard Gardner's theory of multiple intelligences (MI). Although MI theory has been around for 16 years, much of the emphasis and application of multiple intelligences has been written with *children* in mind. Very little has been written on the application of multiple intelligences with adults; the *big* kids I teach!

I have been fascinated with intelligence, creativity, and how people learn ever since elementary school. I was not a good student and was told I had "nothing upstairs." I failed to thrive in a place called school. Yet, I knew I was "smart" in ways that made sense to me. Reading *Frames of Mind: The Theory of Multiple Intelligences* reaffirmed my belief in the untapped learning potential of many people like myself. I am appreciative of Howard Gardner's interest, encouragement, and support in the work I am involved in. I appreciate the support I have received from my colleagues at Glendale Community College. I am *especially* grateful to all the students I have had the pleasure of interacting with over the past few years. Students have allowed me to "stretch" and grow as a teacher and as a person. They have taught me so much about learning, risk-taking, creativity, and having *fun*!

RDL
Glendale, Arizona
April 1999

ACKNOWLEDGMENTS

I have always been in awe of people who write books. Especially books that challenge one to think about human potential, motivation, creativity, and learning. The decision to write this book was an easy one; I have always wanted to write about that which gives me much joy and passion—teaching and learning.

Five years ago when I decided to take a risk and try something new and different (the incorporation and application of MI into my courses), there were a few people who were willing to "go out on a limb" with me, encourage and allow me to pursue an idea. I am grateful to Ann Brandt-Williams, my colleague and friend at Glendale Community College, who has been supportive and actively involved in applying MI/LfU into her classes for as long as I have. I would also like to thank Alberto Sanchez, Glendale Community College, whose support was critical during the "early" days of the MI/LfU pilot study.

I would like to express my gratitude to Kathy Grant, who edited the manuscript. She was patient with me, provided guidance and support throughout the project, took time and spent much energy in providing thoughtful and incisive comments that helped me shape my ideas into a more presentable format. I would also like to thank Marsha Malin, a word-processing whiz who spent countless hours typing the manuscript.

The fine and talented people at John Wiley & Sons have put forth a stellar effort in helping me complete this project. The integrity and sincerity with which this company, and the individuals who comprise it, conduct themselves has made this a memorable experience. Specifically, I would like to thank Jay Beck and all of his colleagues who assisted me. Thanks also goes to Debra Benson for her belief and encouragement in the project. I appreciate the phone call, Deb.

I am grateful to *mi familia,* my family and friends who tolerated my not being around for them because I was "writing the book." Their understanding and love gave me the courage to continue to write about, explore, and challenge beliefs on

how people learn. To my late father, Albert, whose presence was always with me.

Finally, in Chapter One, I tell the story of Javier, the young man who "fell between the cracks" because of an educational process, mindset, and belief that there is only one way of assessing and determining how an individual is "smart" or intelligent. Unfortunately Javier's story is a common occurrence. This book has been inspired by and dedicated to all the Javiers of the world.

CHAPTER ONE

Javier's Story:
What It Means to Be Smart

I remember it well. Vivid and so real, the experience still haunts me. It was a beautiful spring day, and my introductory psychology class had just ended. I felt good about the review we did in preparation for the test the following week. The test would cover the brain and nervous system. "Students who participated in the discussion should do well on the test," I thought to myself, "and the rest, well, I hope they took good notes!"

"This is what I think you were trying to teach us today...."

—19 yr. old dropout

As I gathered my scattered notes from the table next to the lectern, I noticed one student still sitting quietly in his chair at the back of the room. Javier was in deep thought, busy with what appeared to be a drawing or sketching activity. I couldn't help but notice his sense of contentment and enjoyment. He seemed in his own world—a visual world. As I erased the blackboard and Javier continued his drawing, I wondered how many times people (especially teachers!) stereotype students like Javier because of the way they look, dress, or speak.

Javier could have been one of the characters in *Stand and Deliver*, the movie about Jaime Escalante, an inner city high school teacher who motivates kids from "the wrong side of the tracks" to excel in math. To many people these kids look like "losers." This perception, at times, is based on where people live and what they look like. To look at Javier one might think he belonged to a gang. He didn't. He just wanted to "fit in"—typical adolescent behavior.

This wasn't the first time I had noticed Javier's love for drawing. Over the course of the semester he always sat in his

favorite spot—the corner. He didn't bother anyone but did what brought him much joy; he drew. As I prepared to leave the classroom, I asked Javier if today's discussion on the brain made any sense to him. He shrugged his shoulders as if to say, "Yeah, maybe, but what difference does it make anyway? I don't do well on tests, so who cares?"

I was very much aware of his past performances on paper and pencil tests—he bombed them, flunked them terribly. As we continued talking about class and school in general, I told him I had noticed that he drew throughout the entire review session. Not wanting to sound too overly concerned for his lack of notetaking, I asked if I could see what he had drawn. He opened the sketchbook to reveal incredible drawings of the human brain. I stood in awe of their colorful detail. What was even more remarkable, he had drawn the sketches from memory; his book had been closed throughout the class!

"Creative work is play. It is free speculation using the materials of one's chosen form."

—Stephen Nachmanovitch

The drawings included the cerebral cortex, the cerebellum, the corpus collosum, the various lobes, and the two hemispheres. I asked Javier to describe what the drawings meant to him.

He explained in Caló (street venacular), "This area is called the cerebellum. And you know *ése* (a popular salutory expression to a male friend for hello, hi and say "dude"), it's like when somebody gives you a good *cabronazo en la cabeza* ("street talk" for a major blow to the head) and you feel real dizzy. Well, this part organizes bodily motion, posture, *y tambien* (and also) equilibrium."

His example made sense and demonstrated his understanding of the function of the cerebellum. In his side-view sketch of the left hemisphere, I noticed a large, red arrow pointing to Broca's area. "What's this for?" I asked.

"*Pues, tú sabes ése* (well, you know, "dude"), you see, *mi nana* (affectionate name in Spanish for grandmother) suffered a stroke about a year ago on the right side of her body. And as you know, *ése*, the left side of the brain affects the right side of the body, and vice versa! She speaks real slow as if she is really

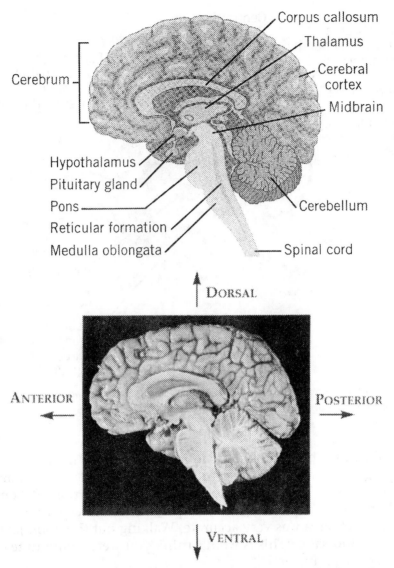

Cross-section of the human brain. The drawing and accompanying photo show a view of the cerebral cortex and the more primitive structures below the cerebrum.

struggling to get the words out. She makes perfect sense in what she is trying to say. We understand her; it just takes time for her to speak in full sentences. There was damage to that area."

Javier continued, telling me about another relative who recently suffered a stroke. "*Mi tío Nicolás* (Uncle Nick) had a stroke, and he speaks real fast and real clear. To hear him you

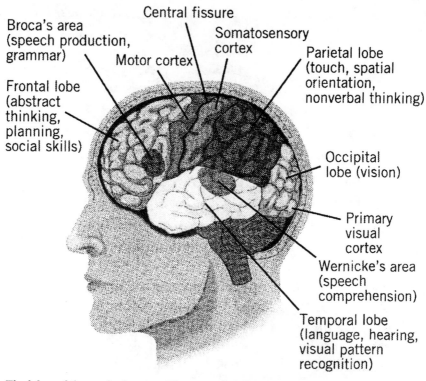

The lobes of the cerebral cortex. The cortex has four lobes, each specialized for different functions and each containing primary and association areas.

would think he was ok, but he makes no sense in what he is saying. It's like the words are all mixed up. There was probably damage here." He pointed to Wernicke's area in the left hemisphere. His explanation, example, and understanding of Wernicke's area was very accurate. Walking out the door, Javier turned and said, "This is what I think you were trying to teach about the brain, Dr. D."

"In teaching it is the method and not the content that is the message...the drawing out, not the pumping in."

—Ashley Montaqu

This exchange occurred over seven years ago, and it still sends chills up my back. Javier "failed" the paper/pencil test on the brain, finished the course with a "D," took a few more classes, then dropped out of college. Despite this, I know he under-

stood; he PERSONALLY understood the brain and its function. So who "failed" whom? Was it a system of higher learning so deeply entrenched in only one way of being "smart" that it failed to recognize and reward the way Javier is smart—his talent and ability to learn and understand academic material in a *different* way? Or was it me, the teacher? The dialogue and demonstration of authentic learning that took place that afternoon has changed the way I look at education, my role as a college teacher, and, more importantly, my understanding of how learning takes place.

WHAT IS LEARNING? WHEN DOES IT OCCUR?

Within the past ten years there has been a proliferation of books, articles, workshops and conferences dedicated to the study, exploration, and implementation of "learning communities," "learning-centered environments," and "learning organizations." Educators—from early childhood to graduate school—are engaged in discussions on how to create these types of environments. Borrowing language from business and industry, college administrators and faculty are spending many hours debating whether to call students "consumers," "clients," or "customers." As one "in the trenches," what I do on a daily basis—interacting with students inside and outside of class—has very little to do with any of the "cutting edge" theories. Most faculty, to the disappointment of administrators, would agree. Faculty members would rather discuss, dialogue, and debate (OK, even argue!) something near and dear to them—learning, and specifically, learning in their disciplines.

"There are no bad students, only discouraged ones."

—Anonymous

Our system of education, to a large degree, is a closed system. Students are taught, tested and classified in terms of two kinds of abilities—their ability to memorize information and, to a lessor extent, their ability to analyze it. As a result, we label students who excel in these abilities as smart or able and students weaker in these abilities as average or even slow or stupid. This method for labeling an individual's abilities begins at a very early age and continues through graduate school. Two

other abilities, creativity and practical application of information—ordinary common sense or "street smarts,"—go unappreciated or unrecognized.

Higher education is deeply ingrained in a system that relies on paper and pencil multiple choice testing for assessment and evaluation. Many of our brightest and most capable learners—from honor students to "at-risk" students—often fail in a system that places too much emphasis on being verbal/linguistic word smart, which comes from "book learning," and logical-mathematical number and/or computer smart. Focusing solely on these two types of learning strategies often encourages rote memory teaching strategies that may foster low student motivation and poor performance. The strategy for many students is to memorize for the test, take it, get it over with, and not care about what is learned because it doesn't mean anything anyway. Many students considered lazy are actually bored and frustrated because, even though they are "smart," they crave multiple methods of stimulation—methods perhaps more effective for helping them master course material.

"Lucky the teacher whose students like to daydream once in a while."

—Anonymous

I propose that the real issue for exploration and dialogue should be in looking at the very core of what learning is and how it occurs. In their quest to find answers, many social scientists are leaving their laboratories to study the schools. A growing number of cognitive scientists are realizing that people learn, not in a vacuum, but through social interaction. Other researchers are studying motivation, attempting to understand what makes people want to learn. Studies in neurology challenge the common metaphor that the brain is like a linear computer waiting for programming. Scientists are now telling us the brain, a flexible, self-adjusting organism, grows and reshapes itself in response to challenge and withers through lack of use.

I CAN'T WRITE ABOUT THAT!

I have had an interest in cognitive psychology for the past fifteen years. Studies on problem solving, intelligence and IQ

tests, learning environments, and creativity intrigue me. From a personal point of view, being labeled "mentally retarded" and a "slow learner," as a child, has added to my professional interest in what it means to be "smart." I have never done well on paper and pencil tests. Like many other "successful" people, I learned to rote memorize, regurgitate, give back to teachers what they wanted to hear, "earn" the grade and move on to the next class.

Was all of my schooling like this? No. I did have those rare teachers who challenged me to think and reflect upon the things I was learning. These gifted, risk-taking individuals chose to "color outside the lines" and provided opportunities to connect academic theories and "book learning" to real-life. In addition to applying what I was learning to the "real world," these teachers also taught me how to use "common sense." Little did I know then the influence those teachers would have on my choice of a profession and how I would view my role as a teacher.

"With courage you will dare to take risks, have the strength to be compassionate and the wisdom to be humble. Courage is the foundation of integrity."

—Keshavan Nair

I am not a famous psychologist or a theorist. I haven't written any books prior to this one. And even though I enjoy doing research, first and foremost, I am a teacher. Actually, like most "veteran" academics (25 years), I have spent all my adult life "in college," and yes, I do have a life, but realistically, a large portion of my life revolves around my profession. I sense this is true of most academics.

Over three years ago, I began thinking about writing a book on my experiences, thoughts, and feelings about teaching, learning, change, and renewal. I read everything I could get my hands on pertaining to the frightening and exhilarating experience of writing. All the books seemed to suggest the same thing: To write is to be real and be yourself. In writing, as in life, however, "being yourself" is easier to propose than practice. Being ourselves immediately raises the stakes of rejection, resulting in writing anxiety. It's no wonder so many writers struggle ingeniously to hide behind verbiage and prose. The facts of the matter are less demanding to write about than feelings.

Inflated language, obscure references, and needlessly complex sentences sometimes surround authors with a dense cloud of verbal fog. The boldest writers of all are those who leave no doubt in the reader's mind about what they want to say. In a speech to the Association of American University Presses, Patricia Nelson Limerick, a history professor at the University of Colorado, tried to make sense of her colleagues' preference for intellectual jive talk. Limerick thinks it is a product of their timidity. "Professors are often shy, timid and even fearful people," she told her audience, "and under those circumstances, dull, difficult prose can function as a kind of protective camouflage."

"A ship in port is safe, but that's not what ships were built for."

—Grace Hopper

From graduate school on, Limerick explained, career academics learn that terrible sanctions can be imposed on those who express themselves in ways that make sense beyond the academy's walls. To timidity, one might add laziness as a reason for generating fog. Saying exactly what one means is hard work. As Sir Ernest Gowers suggests in his book, *Plain Words*, "To express one's thoughts accurately is hard work, and to be precise is sometimes dangerous."

Instead of hiding behind the verbal fog, my goal in writing this book is to make it appealing and applicable to a wide audience interested in human potential, learning, and what it means to be smart. Free of academic "jargon," my approach and style will be very user friendly. I have included a bibliography, *including* scholarly research, in the back of this book.

CHAPTER TWO

The Quiet Revolution: The Brain and Intelligence

THE NATURE OF INTELLIGENCE OR THE NURTURE OF IT?

A question that has and will be debated long after we are gone is: are we who we are because of *nature* (our genetic makeup) or *nurture* (our environment)? In the middle of all this is the concept of intelligence, which has never been so hotly debated as it is today. Recently, a group of two dozen prominent theorists were asked to define intelligence, and they gave two dozen somewhat different definitions. Individuals differ from one another in their ability to understand complex ideas, adapt effectively to an environment, learn from experience, and engage in various forms of reasoning. This all makes understanding the nature of intelligence more challenging and complicated.

DENDRITES, ENRICHED ENVIRONMENTS, AND LEARNING

Within the past ten years we have learned more about the human brain than ever before. New imaging technologies—PET and CAT scans and MRIs, etc.—now make it possible for researchers to see inside living brains and examine the components and functions at work. We have entered an era of extraordinary discovery. I believe the future of teaching and learning lies in the study and understanding of the brain. The process of learning is both wondrous and complex.

"The growth of the human mind is still high adventure, in many ways the highest adventure on earth."

—Norman Cousins

Researchers tell us brain activity occurs in a number of ways: spontaneously, automatically, and in response to challenge. To

learn effectively, brain activity must be *stimulated* in at least one of these ways and be supported by useful and suitable feedback systems. Moreover, for learning to continue, the brain must receive *challenging* tasks requiring significant amounts of reflection or emotional energy. This challenge is an important part of healthy brain functioning.

For example, even if I know the location of my favorite Mexican restaurant, I won't be motivated to go there until I am hungry. In addition, many behavioral changes may be the result of maturational developments. A young child may fear darkness, while an adult doesn't show an emotional reaction to being in the dark. Potty-training, it could be argued, includes both maturation and learning. Yet, parents know little Mary is not going to be potty-trained until she is good and ready, physically and emotionally!

According to researchers, the brain grows dendrites, thread-like extensions that grow out of neurons (specialized cells of the nervous system), while learning is taking place. Learning involves forming new connections between neurons, a process most prolific during childhood. According to the experts, more connections among the brain's estimated billion neurons means a better functioning brain.

Connections come from inherited growth patterns and in response to stimuli. An incredible process takes place. Electrical impulses are sent to the brain and trigger the release of messenger chemicals that induce more electrical impulses as they travel from one neuron to another. This electrochemical process, the basis of brain communication, sometimes stimulates growth of new dendrites. In the laboratory, rats raised in an environment with more "toys" appear to have more brain mass—probably from more dendrites—than rats in an environment with less stimulation. If stimulation and an enriched environment trigger brain growth and development in rats, what are the implications for humans? Are we providing enriching, intellectually stimulating environments for children—at home and at school? Are *we* in enriching, intellectually stimulating environments?

With enrichment we continue to grow dendrites; with impoverishment we continue to lose them. The brain is *the* organ for learning. When brain cells are stimulated, their structure and chemistry change, too. This ability of nerve cells to change is called the brain's plasticity. Unlike other cells in the body, when neurons die they are never replaced with new ones.

Dendrites

Cell body
Nucleus

Direction
of nerve
impulse

Axon

Terminal
buttons

(a) (b)

The anatomy of a neuron. The branched fibers called dendrites receive neural information from other neurons and pass it down the axon. The terminal buttons then release neurotransmitters, chemicals that transmit information to other cells.

The brain cells we are born with are all we will ever have. Isn't it to our advantage to engage in activities that will keep neurons alive and growing? At the core of much of the educational

reform movement today is the idea of providing children—and adults—with an enriched environment, taking into account the diversity of students and their learning styles, intelligences, or ways of being "smart." In higher education, we speak of "paradigm shifts" in learning, "student-centered" learning, and the "revolution" in learning. Yet, I'm not sure if we have taken the time to discuss what learning is and when it occurs. What do we mean by the term learning?

"The true aim of everyone who aspires to be a teacher should be, not to impart his own opinion, but to kindle minds."

—Frederick W. Robertson

Learning is defined as a process resulting in a relatively permanent change in behavior due to experience and reinforcement. Therefore, learning reflects a change in the potential for a behavior, but it doesn't automatically lead to a change in a behavior. Motivation plays a major role in translating learning into behavior.

A QUIET REVOLUTION

A quiet revolution has been taking place in our country over the past few years. This revolution is centered around learning, intelligence, and what it means to be "smart." Over the past four or five years a proliferation of books and movies has challenged us as a society to determine and redefine "smartness."

From the Bell Curve to Forrest Gump

In the fall of 1994, the publication of Herrstein and Murray's book *The Bell Curve: Intelligence and Class Structure in American Life* revived a new round of debates regarding the purpose, usefulness, and accuracy of intelligence test scores and the nature of intelligence. The book suggests there are two types of people in this country with respect to intelligence. This notion is based on a genetically influenced two-tier division that results when the children of high-IQ, white professionals attend elite colleges and universities and meet and marry the children of other high-IQ, white professionals. According to the authors, the children of high-IQ couples are statistically more likely to have higher IQs than the children of low-IQ parents.

Throughout this century whites have outscored blacks and Hispanics on IQ tests as well as standardized achievement tests. Are certain groups of people in society "smarter" than others because of their parentage? Or is it a case of the haves versus the have nots?

"Challenge your mind. Stretch and exercise it like any part of your body."

—Anonymous

Intelligence test performance is related to years of formal education. From its earliest inception, IQ testing was designed to assess school performance. Research shows that there are many factors associated with intelligence, including genetics, socioeconomic status, home environment (intellectually stimulating?) and access to formal education. Interestingly enough, at about the same time as the publication of the highly controversial book, Hollywood released a movie that rocketed to box-office history and touched the heart of filmgoers like no other movie: *Forrest Gump*. Can anyone ever forget how Forrest deals with adversity and challenge in his life? His response is:

"Life is like a box of chocolates. . . You never know what you're going to get."

Gump touched a cord in all of us. From having a physical disability, to becoming a football star and a business tycoon, with innocence that never wavers in terms of right and wrong, Gump's heart knows what his limited IQ cannot. His successes become inspiration for us all. In spite of all the ridicule, teasing, and name-calling, he endures. Forrest triumphs in the end, leaving us with the now classic, "Stupid is as stupid does!" I find it ironic that two different mediums—a scientific research book and an Academy award-winning movie—caused so much discussion, characterized by strong assertions as well as strong feelings. Perhaps more fuel for the nature/nurture fire!

"I don't have a lot of respect for talent. Talent is genetic. It's what you do with it that counts."

—Martin Ritt

CHAPTER THREE

Multiple Intelligences Theory: The Last Sixteen Years and the Future

It has been sixteen years since the first publication of the Howard Gardner's now classic, *Frames of Mind*. Gardner, a developmental psychologist and neuropsychologist, is critical of contemporary views on intelligence within the discipline of psychology. He argues against the limited thinking of intelligence as a single, underlying capacity that enables individuals to solve problems with abstract reasoning.

Gardner is also critical of the conventional assessment of intelligence that relies heavily on paper and pencil testing. He argues that traditional IQ tests only address linguistic and logical-mathematical abilities. Some people have the ability to think in words and to use words and language to express and appreciate complex meanings. For example, lawyers, journalists, poets, and politicians possess strong linguistic intelligence (word smart). Having logical-mathematical intelligence (number smart) involves the ability to perceive patterns and approach problems logically, make inferences, calculate, quantify, and carry out complex mathematical operations. Scientists, engineers, accountants, and computer analysts tend to have strong logical-mathematical intelligence. Most tests of intelligence, and most scholastic measures, focus only on these two intelligences. Gardner believes that people possess additional intelligences, which most standardized tests fail to assess.

"Trust that still, small voice that says, 'this might work and I'll try it.'"

—Diane Mariechild

In challenging the established intelligence theories, Gardner drew upon findings from evolutionary biology, anthropology, developmental and cognitive psychology, neuropsychology, and psychometrics. He studied patterns of devel-

opment in normal children and adults and patterns of abilities in brain-damaged and stroke patients, child prodigies, autistic children, and idiot savants. Gardner's research led him to his Multiple Intelligences (MI) Theory.

Gardner's MI theory proposes there are at least six other intelligences—ways of being smart—including spatial (visual), musical/rhythmic (music), bodily-kinesthetic/movement (body), interpersonal (people), intrapersonal (self), and naturalist (flora and fauna). In Gardner's framework, each person possesses all eight intelligences, and individuals combine and blend them in various ways in the course of solving problems and learning. Gardner's theory has been met with either enthusiasm, controversy, or luke-warm interest in the psychological community. However, the educational community has embraced the theory's tenets of honoring the diversity and giftedness of each individual.

Gardner argues that intelligence is not some static reality fixed at birth and measured well by standardized testing. Instead, he believes that intelligence is a dynamic, ever-growing reality that can be expanded in one's life—in or outside of school—through the eight or more intelligences.

"Our prescription to an adult approaching a new learning task is for him to become as a child again, to tap the wellsprings of his suppressed imagination that has lain buried under years of linguistic development."

—G. H. Boner

THE INTELLIGENCES: ABILITIES, CAPACITIES, TALENTS, POTENTIAL

Respecting the differences in human intelligence will lead to a new kind of educational system and a new way of thinking about what it means to be intelligent, or smart. In the old way of thinking, intelligence is defined according to how well one does on a test. Those who are talented in the use and understanding of words—reading, writing, and speaking—as well as others who can engage in abstract reasoning are considered "smart." From an expanded viewpoint, Gardner suggests that intelligence is the ability to solve problems or make something

that is valued in one or more cultures or societies. In his recent work on creativity with Feldman and Csikszentmihalyi, he has altered and expanded the notion of intelligence to include a more "holistic" approach. Gardner (1995) says:

> An intelligence is a biological and psychological potential that is capable of being realized to a greater or lessor extent as a consequence of the experiential, cultural, and motivational factors that affect a person. (p. 202)

In my way of thinking, people's special talents, or "gifts," are intelligences as well.

Actually, Gardner has a very precise yardstick to determine if an ability qualifies as an intelligence. Examples of the criteria include:

1. Is there a particular representation in the brain for the ability?
2. Are there special populations that exhibit the autonomy of the candidate intelligence (i.e., idiot savants, child prodigies, stroke and brain-damaged patients)?
3. Is the intelligence rooted in evolutionary history? Can the candidate intelligence be seen in animals other than human beings?
4. Is there evidence of the intelligence from psychometric findings? Standardized tests can provide explicit evidence of the existence of an intelligence and add to its validity and reliability. The absence of high correlations on psychometric assessments may indicate the relative autonomy of the intelligences (i.e., spatial and logical).
5. Does the intelligence follow a distinctive developmental path, resulting in an "expert" end-state (i.e., spatial = artist, sculptor, architect, navigator)?
6. Can the intelligence be encoded (converting information into a code that can be communicated) into a symbol system like written language, dance and music notation, or drawing?

I believe MI is an opportunity to begin dialogue and discussion among people responsible for learning environments—families, schools, and the workplace—to begin talking about what is important, what they value, and what kind of learning and work environment will bring out the *best* in people. For those interested in the empirical or research findings on the

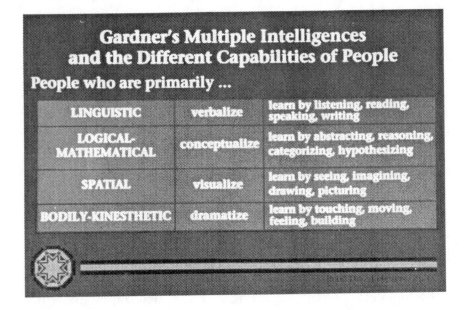

Gardner's Multiple Intelligences and the Different Capabilities of People

People who are primarily ...

LINGUISTIC	verbalize	learn by listening, reading, speaking, writing
LOGICAL-MATHEMATICAL	conceptualize	learn by abstracting, reasoning, categorizing, hypothesizing
SPATIAL	visualize	learn by seeing, imagining, drawing, picturing
BODILY-KINESTHETIC	dramatize	learn by touching, moving, feeling, building

development of multiple intelligences theory, I strongly suggest reading Gardner's *Frames of Mind*. The "nay-sayers" and those who believe MI is "just another fad that will soon fade," must understand that no empirically based theory is ever permanently established. This is what research is all about—old claims being challenged by new findings. The most significant

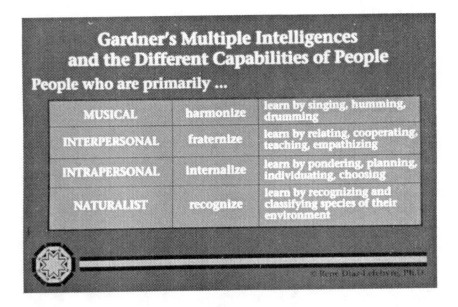

Gardner's Multiple Intelligences and the Different Capabilities of People

People who are primarily ...

MUSICAL	harmonize	learn by singing, humming, drumming
INTERPERSONAL	fraternize	learn by relating, cooperating, teaching, empathizing
INTRAPERSONAL	internalize	learn by pondering, planning, individuating, choosing
NATURALIST	recognize	learn by recognizing and classifying species of their environment

aspect of MI for me is Gardner's position that it is a theory of the intellect, rather than an educational prescription. Recognizing that we don't all have the same kind of minds, MI challenges us to provide learning and working environments that recognize the differences in mental abilities and strengths each person has. The concept of multiple intelligences, in theory and in practice, is about the *personalization* of education and learning.

RANK ORDER, CONDITIONING, OR WHAT IS VALUED

I often wonder why explanations of multiple intelligences always begin with linguistic (word smart) and logical-mathematical (number smart) intelligences and then follow with the six other intelligences. In my own explanation, I must admit, I too usually begin with the two "traditional" intelligences. Why start out with these two? If one believes in the plurality of the intelligences, perhaps a paradigm shift is needed, giving equal value to each one.

"Why not go out on a limb? Isn't that where the fruit is?"

—Frank Skully

The Personal Intelligences: Interpersonal and Intrapersonal

Frequently, people ask how MI theory is related to emotional intelligence. Over eight years ago, the phrase "emotional intelligence" (EQ) was coined by psychologists Peter Salovey of Yale and John Mayer of the University of New Hampshire. Emotional intelligence is by definition a complex, multifaceted quality, representing non-quantifiable elements such as self-awareness, empathy, persistence and social deftness. People with high EQs are self-aware, have empathy for the feelings of others, and regulate their own emotions in a way that enhances *living*. The EQ rally motto is: maybe people with high IQ's get the jobs; but it is the people with high EQ's that keep the jobs! The MI theory recognizes a person's personal intelligences—interpersonal and intrapersonal skills—as ways of being smart. The personal intelligences and EQ share many characteristics. If there is a cornerstone to emotional intelligence (on which most

other emotional skills depend) it is a sense of self-awareness, of being smart about what we feel.

"Adventure is not outside a man, it is within."

—David Grayson

Interpersonal Intelligence: People Smart Interpersonal intelligence is the ability to understand other people, what motivates them, how they work, and how to work cooperatively with them. Interpersonal intelligence also suggests a sensitivity to others' needs and viewpoints. This intelligence operates primarily through person-to-person relationships and communication. Interpersonal learners enjoy being around people, have many friends, prefer social activities, and learn best by relating and participating in cooperative learning groups. Further, this type of learner expresses empathy for the feelings of others, can respond to individual moods and temperament, and enjoys participating in group activities. One common myth surrounding interpersonal intelligence is the notion that people with these skills learn best by engaging in cooperative learning activities all of the time! As with any strategy or technique, moderation and common sense must prevail; too much of anything gets boring and predictable—for the student and

"Life is like a ten-speed bike ... most of us have gears we never use."

the teacher! The MI approach is one of many tools. There needs to be a clear and specific purpose for having students engage in group activities in the first place. If the teacher is not clear on the connection between the group exercise and what is being taught, then the results can be disastrous and a waste of valuable class time. Assessing the learning environment—the people involved, the time of day, the topic discussed—is probably the most effective method for determining whether a group activity is appropriate and worthwhile.

Intrapersonal Intelligence: Self Smart Intrapersonal intelligence is the ability to access and distinguish among one's own feelings. It involves an awareness of one's own strengths and weaknesses. Students with keen intrapersonal skills learn by planning, choosing, pondering, and individuating for themselves. They typically enjoy solitude and prefer working alone. This intelligence relies on inner states of being, self-reflection, introspection, and metacognition (thinking about one's own thinking). Intrapersonal learners prefer their own inner world and have a deep sense of self-confidence and independence. They typically have a strong will and motivate themselves to do well on independent study or work projects. They often respond with strong opinions when controversial topics are discussed. Common myths associated with people who possess this intelligence are that they tend to be introverts, do not like people, are antisocial, shy, not very confident in their abilities, and have low self-esteem.

"A child explores and learns with no sense of failure or limit. Recovering that child within is the key to accelerated learning."

—David Meier

Musical/Rhythmic Intelligence: Music Smart

Musical intelligence helps people make meaning out of sound. Individuals having this ability or talent are sensitive to a variety of nonverbal sounds in the environment, and they characteristically play a musical instrument and enjoy listening to music. These individuals tend to remember songs' melodies and can tell when a musical note is off-key. Musical intelligence includes the ability to produce and appreciate rhythm, pitch,

tonal patterns, and timbre, the forms of musical expressiveness. Musically intelligent learners often prefer to have music playing while studying or reading. These individuals might be able to concentrate better while taking a test or working on a project if allowed to listen to certain types of music.

"Compared to what we ought to be, we are only half awake. We are making use of only a small part of our physical and mental resources."

—William James

Bodily-Kinesthetic Intelligence: Body Smart

Bodily-kinesthetic intelligence is associated with physical movement and the knowings/wisdom of the body. It is related to the brain's motor cortex, which regulates bodily motion. Bodily-kinesthetic learners process knowledge through bodily sensations and use their bodies in differentiated and skilled ways. They need opportunities to move and act emotions out; they like to touch, feel, and build. They respond best in a learning or work environment that provides manipulatives—action-packed stories, role-playing, simulations, physical activities, and hands-on learning experiences. These individuals are often adept at performing motor skills gracefully. Bodily-kinesthetic intelligence capitalizes on an individual's capacity to control bodily movements and handle objects skillfully. Learning by doing is a key component of this intelligence.

Verbal/Linguistic Intelligence: Word Smart

Linguistic intelligence relates to words and language, written and spoken. This form of intelligence, often called one of the "traditional" intelligences, dominates most Western educational systems, especially higher education. Linguistic learners have highly developed auditory skills, enjoy reading and writing, like to play word games, and have a good memory for names, dates, and places. They possess well-developed vocabularies, use language fluently, and are often able to spell words accurately and easily. People high in linguistic intelligence often excel in educational settings where reading, writing, speaking, and listening are encouraged, valued, and rewarded. "Booklearning"

tends to come fairly easily for people with strengths in this type of intelligence.

Visual/Spatial/Imagination Intelligence: Picture Smart

Visual intelligence relates to the sense of sight and being able to visualize an object and create internal, mental images/pictures. Spatial learners think in images, pictures and colors; they enjoy art activities like reading maps, charts, and diagrams. They respond positively to movies, slides, pictures, and other visual media. Spatial learners visualize clear images when problem solving and thinking about concepts; they enjoy doing jigsaw puzzles and solving artistic problems. People with strong visual skills need to see or imagine concepts and enjoy using creativity and imagination in a class or work project.

"When you start a painting, it is somewhat outside you. At the conclusion, you seem to move inside the painting."

—Fernando Botero

People who learn visually might say, "Don't just give me a book to read or lecture to me; instead, let me see it, visualize it!" They tend to learn concepts more easily when allowed to exhibit comprehension through art. Another example of spatial intelligence is in playing board games like chess. Chess requires the ability to visualize objects from different perspectives and angles. Visualizing and manipulating mental models in the "mind's eye" is an enjoyable and important strategy for the spatial learner.

Logical-Mathematical Intelligence: Logic or Number Smart

Logical-mathematical intelligence—often called scientific thinking—is associated with deductive thinking/reasoning skills. People with sharp logical intelligence enjoy working with numbers and have the capacity to recognize patterns and work with abstract symbols. They enjoy problem solving that requires sequential order, like mathematics, and prefer to experiment, testing what they don't understand. Logical learners learn best by forming concepts and looking for categories and relationships. Activities need to be fully explained and justified before they make any sense to them. This learner thrives when given the opportunity to solve problems, reason logically and

clearly, and interact with computers and other technology. Activities which teach sequence, prediction, cause and effect, and other cognitive learning processes provide an optimal learning environment for the logical-mathematical learner. Along with linguistic intelligence, individuals with the ability to work with numbers and computers tend to be more recognized, rewarded, praised, and compensated for their skills. Logical-mathematical intelligence is also considered a "traditional" intelligence.

Naturalist Intelligence: Environmental Smart

Gardner believes there is a possibility of more intelligences as long as the potential intelligence meets the criteria established for the first seven. Recently, he has identified the naturalist intelligence as the newest way of being "smart." The naturalist is someone who is able to recognize flora and fauna, can make distinctions in the natural world, and has the ability to observe, identify, and classify plants, minerals, and animals. Naturalists see patterns in the natural world around them and seem to notice detail and change in the environment. This type of learner thrives on activities such as hunting, fishing, ranching, farming, and any of the biological sciences (i.e., biology, botany, zoology, and ecology). A naturalist might enjoy collecting rocks, shells, leaves, and flowers. Gardner cites Charles Darwin as an example of naturalist intelligence because of his ability to identify insects, fish, birds, and mammals. One of the key elements of the naturalist intelligence is the ability to identify, categorize, sort, and organize things in the total environment—not just nature.

The application of the naturalist intelligence is a challenge for educators. Some argue its application is more appropriate and effective with younger children as they have a "natural" tendency to explore the natural world with awe. I don't think it is an accident that most young children become fascinated with dinosaurs!

"Patience is the ability to idle your motor when you feel like stripping your gears."

—Anonymous

THERE ARE NO QUICK FIXES!

Despite the widespread popularity of multiple intelligences theory, unfortunately, there are many common "myths" about MI and learning in general. Before I proceed on how I developed and implemented the MI/LfU Pilot Study in the Glendale Community College psychology curriculum, I will attempt to address some misconceptions and myths surrounding MI.

1. A current "buzzword" in education is that the Theory of Multiple Intelligences is a passing fad because it is not based on empirical evidence.

 Fact: MI theory is a *scientific theory* based on numerous studies and findings over a sixteen year period. MI theory and application has expanded beyond the educational and psychological community to business, industry, and the community in general. MI challenges society to look at the abilities and potential we ALL have as well as acknowledge the different combinations of intelligences and strengths each person has. MI theory—as should be with any other theory—is constantly being studied and researched with new findings from the field and the lab.

2. An intelligence is the same as a "learning style," and both terms can be used to describe "how" a person learns.

 Fact: Learning-style theory has dominated the discussion and debate on how people perceive and react to the world since 1927, when Carl Jung noted major differences in people's personalities in regard to their perceptions, how they made decisions, and how active and reflective they were while interacting. MI theory goes beyond the limitations of psychometric testing to measure intelligence. In essence, learning styles are concerned with the *differences* in the process of learning, whereas multiple intelligences focus on the *content* and *products* of learning.

3. MI theory is closely tied to personality, motivation, attention, and other psychological theories.

 Fact: MI is not about personality, will, morality, attention, motivation or any other theory relating to the human organism. There is no official "MI way" of doing things! MI is not about values, morals or any other notions that individuals, schools, or communi-

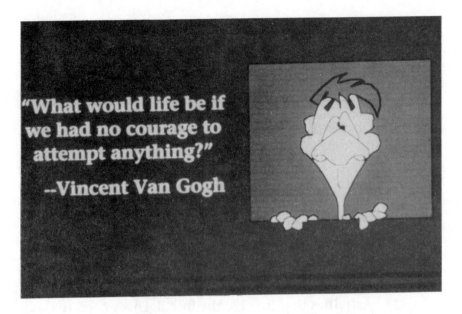

"What would life be if we had no courage to attempt anything?"

--Vincent Van Gogh

ties determine for themselves. Often teachers make the mistake of equating a student who is intrapersonally intelligent with being introverted or antisocial. Another misconception results from making the assumption that students who score high in interpersonal intelligence will want to be in and will thrive in a cooperative learning environment. From experience, I know this is not necessarily true! Human beings can't be put into a category and labeled. Instead of saying "this learner is a spatial learner," we need to be asking "what are the different ways this person learns best?" Because MI is a theory of the mind, the more knowledge a teacher has on how a student thinks, the better she can assist him in learning material in a way that makes sense to him.

4. The best way to assess and "teach" the eight intelligences is to create eight different tests and present material in eight different ways.

 Fact: A series of tests is inconsistent with the basic thesis of MI theory. To present a day's lesson while attempting to utilize all the intelligences is foolish, a gross waste of valuable learning time, and in essence, is a lot of work that serves no purpose in the personalization of education.

> "Real learning comes about when the competitive spirit has
> ceased."
>
> —J. Krishnamurti

5. MI theory is the panacea in education we all have been
 waiting for!

 Fact: Anyone who believes this statement is either naive,
 has not kept up with the findings in cognitive sci-
 ence, does not use "common sense," or knows some-
 thing you and I don't! There is not a singular,
 "correct" translation of MI theory into pedagogical
 practice. MI is simply a tool which can be applied in
 many different ways toward a variety of educational
 ends; MI is not, however, an end unto itself.
 Activities that involve the intelligences need to be
 well thought out, planned and held accountable to
 the same high standards of any other "tool" utilized
 in the learning process.

The Personalization of Education

Multiple intelligences theory is a claim about the evolution of
the human mind/brain. All human beings, according to
Gardner, possess all the intelligences and all can enhance the
ensemble of intelligences through practice; however, because of
genetic and environmental factors, no two individuals exhibit
exactly the same profile of intelligences. MI theory has been
seen as a charter for personalizing education—for making sure
that each child's own strengths (and weaknesses) are taken into
account in and outside of school. I view the incorporation of
MI theory into higher education curriculum (and any other
curriculum) as an opportunity to take learner differences seri-
ously by giving learners a chance to solve real-life problems in
meaningful and multiple ways. In Gardner's own words, "MI
education is about providing children with those crystallizing
experiences that connect them to something that engages
curiosity and stimulates exploration." He sees multiple intelli-
gences as a theory about the intellect, not an educational pre-
scription. As with any new theory, it is important the
application of MI incorporate both a strong empirically-based
and evaluative component.

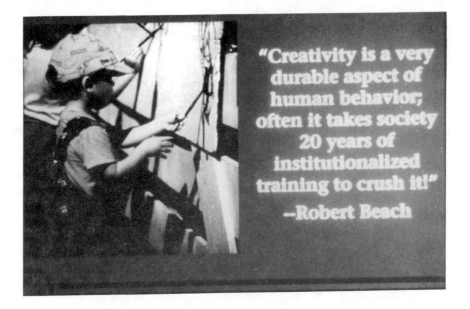

"Creativity is a very durable aspect of human behavior; often it takes society 20 years of institutionalized training to crush it!"

--Robert Beach

"The aim of education should be to convert the mind into a living fountain, not a reservoir."

—John Mason

WHAT IF . . .

I listened attentively at a conference seven years ago as fellow teachers talked about how they transformed their classrooms by including Howard Gardner's theory of multiple intelligences (MI) in their curriculum. In these classrooms, students were excited about learning. A 10-year veteran teacher said that since applying the theory, her students now demonstrate a genuine love of learning. As I listened to these inspirational teachers describe what they were doing, I could not help but feel a tinge of envy. They seemed to be having so much fun teaching and reaching students.

These elementary teachers talked about how every child is smart in his own way and how MI theory has enhanced their understanding of teaching and how children learn. I thought to myself, "Yeah, okay, this sounds like a great idea for the little kids, but I teach the big kids at college level. It will never work—or will it?"

MI THEORY SUMMARY CHART

	Core Components	Symbol Systems	High End-States	Neurological Systems (Primary Areas)
Linguistic	Sensitivity to the sounds, structure, meanings, and functions of words and language.	Phonetic languages (e.g., English)	Writer, orator (e.g., Virginia Woolf, M.L. King)	Left temporal and frontal lobes (e.g., Broca's/Wernicke's areas)
Logical-Mathematical	Sensitivity to and capacity to discern logical or numerical patterns; ability to handle long chains of reasoning.	Computer languages (e.g., Pascal)	Scientist, mathematician (e.g., Madame Curie, Blaise Pascal)	Left parietal lobes; right hemisphere
Spatial	Capacity to perceive the visual/spatial world accurately and to perform transformations on one's initial perceptions.	Ideographic languages (e.g., Chinese)	Artist, architect (e.g., Frieda Kahlo, I. M. Pei)	Posterior regions of right hemisphere
Bodily-Kinesthetic	Ability to control one's body movements and to handle objects skillfully.	Sign language; braille	Athlete, dancer, sculptor (e.g., Jesse Owens, Martha Graham, Auguste Rodin)	Cerebellum, basal ganglia, motor cortex
Musical	Ability to produce and appreciate rhythm, pitch, and timbre; appreciation of the forms of musical expressiveness.	Musical notational systems; Morse Code	Composer, performer (e.g., Stevie Wonder, Midori)	Right temporal lobe
Interpersonal	Capacity to discern and respond appropriately to the moods, temperaments, motivations, and desires of other people.	Social cues (e.g., gestures, facial expressions, etc.)	Counselor, political leader (e.g., Carl Rogers, Nelson Mandela)	Frontal lobes, temporal lobe (especially right hemisphere), limbic system
Intrapersonal	Access to one's own feelings and the ability to discriminate among one's emotions; knowledge of one's own strengths/weaknesses.	Symbols of the self (e.g., in dreams, art work, etc.)	Psychotherapist, religious leader (e.g., Sigmund Freud, The Buddha)	Frontal lobes, parietal lobes, limbic system

Developmental Factors	Ways That Cultures Value	Evolutionary Origins	Presence in Other Species	Historical Factors (relative to U.S. in 1990s)
"Explodes" in early childhood; remains robust until old age	Oral histories; storytelling, literature, etc.	Written notations found dating to 30,000 years ago	Apes' ability to name	Oral transmission more important before printing press
Peaks in adolescence and early adulthood; higher math insights decline after age 40	Scientific discoveries, mathematical theories, counting and classification systems, etc.	Early number systems and calendars found	Bees calculate distances through their dances	More important with influence of computers
Topological thinking in early childhood gives way to Euclidean paradigm around age 9-10; artistic eye stays robust into old age	Artistic works, navigational systems, architectural designs, inventions, etc.	Cave drawings	Territoriality instinct of several species	More important with advent of video and other visual technologies
Varies depending upon component (strength, flexibility, etc.) or domain (gymnastics, baseball, mime, etc.)	Craft works, athletic performances, dramatic works, dance forms, sculpture, etc.	Evidence of early tool use	Tool use of primates, anteaters, and other species	Was more important in agrarian period
Earliest intelligence to develop; prodigies often go through developmental crisis	Musical compositions, performances, recordings, etc.	Evidence of musical instruments back to Stone Age	Bird song	Was more important during oral culture, when communication was more musical in nature
Attachment/bonding during first three years critical	Political documents, social institutions, etc.	Communal living groups required for hunting/gathering	Maternal bonding observed in primates and other species	More important with increase in service economy
Formation of boundary between self and others during first three years critical	Religious systems, psychological theories, rites of passage, etc.	Early evidence of religious life	Chimpanzees can locate self in mirror; apes experience fear	Continues to be important with increasingly complex society requiring ability to make choices

CHAPTER FOUR

Stimulating Desire and Motivation to Discover the Joy of Learning

My techniques weren't working for my students and me. I had to do *something*. I could no longer rest on the belief that spending most of my teaching career lecturing and giving paper/pencil tests was the *best* way for students to learn.

Could it be I wasn't reaching as many students as I thought? I was always prepared for my lectures. I even made the effort to tell different "jokes." For some reason, however, my students were not "getting it." They often appeared disinterested, unmotivated, and yes, even bored.

Recognizing this was a hard pill to swallow. I could have retreated into the "blame game." It is easy to just blame society, parents, high schools, and obviously, the students themselves for not being academically prepared and motivated. Instead, I decided to find better answers to my dilemma.

RISK-TAKING AND COMFORT ZONES

Over the past four years I have had the opportunity to speak with many dedicated college teachers and business and industry trainers across the country about teaching and learning, assessment and evaluation, creative grading, and change. I have found that most teachers have a passion for their discipline or training area and care about students. However, many of us teach as we were taught and grade as we were graded. Often we rely on repeating procedures in our classrooms because they have "worked" for so long. Or have they? It is human nature to engage in activities that feel comfortable, enhance self-esteem, and allow for a sense of competence and confidence. But what if these activities become inadequate?

"And the trouble is, if you don't risk anything, you risk even more."

THE MI PILOT STUDY

I decided it was time to take action. At the end of a spring semester, I met with Glendale Community College administrators and proposed a two-year pilot project plan. The deans appeared apprehensive at first, asking the usual questions: "How much is this going to cost? Will you teach this as an overload or do you want release time? Why a two-year project?" Because of the experimental nature of the project, I indicated I needed at least two years to work with a variety of learners, to collect, analyze, and evaluate data.

As I answered the administrators' questions about the project, I remember saying, "Many of our students are falling between the cracks. We are losing them. Even though our whole system of higher learning is based on paper/pencil testing, not every college student learns best in this manner. Furthermore, if we are to prepare our students for the next century, maybe we need to look at learning in a whole different way." The incorporation and application of multiple ways of assessment and learning for understanding are not going to take place at our research universities; that's not their role. However, the timing is right for the community college to become a leader in higher education for redefining what it

means to be "smart." One of the deans remarked, "You sound so convincing that it might work."

I concluded my presentation by saying, "Look, I guess the bottom line is that I am willing to take some professional risks, get out of my comfort zone and go out on a ledge. Are you willing to go out on the ledge with me? Are you willing to take risks and be supportive of the venture?"

The framework for affecting institutional change, with the goal of improving student learning, begins with risk-taking, going out on a limb, asking "what if?" instead of saying "it can't be done!" Needless to say, I am very fortunate. The project has received full support from the GCC administration and departmental leadership since we began in 1994.

"It is not because things are difficult that we do not dare; it is because we do not dare that they are difficult."

—Seneca

ASSESSMENT AND BEYOND

Assessment has become a *primary* focus at many community colleges, along with such related concepts as accountability, effectiveness, efficiency, productivity, student outcomes, and quality improvement. Community colleges have a long history of leadership in the assessment movement. We do a good job of identifying students' academic readiness by testing them in reading, writing, and math and then placing them accordingly. I suggest we take this a step further and assess students in their individual learning potential.

This is how the idea of a MI/LfU pilot project began. I simply asked the question, "what would it be like teaching a college-level class designed to assist students by identifying, acknowledging, and yes, even encouraging different ways of being smart?" In addition, what would happen if I provided them learning options and choices, utilizing different intelligences? After all, isn't real life made up of choices and options we select from, act upon, and hopefully, learn from? At stake is the very essence of learning itself. What is learning? When and how does it take place? Further, there are distinct characteristics in each of the intelligences. Understanding the strengths

of the dominant intelligences of each student may create an environment free of rigidity by the *unlocking* of their minds and potentials.

THE CHANGING ROLE OF THE TEACHER

All across the country I hear my colleagues commenting that today's student is so *different* than when we started teaching. The teachers are "baby boomers," and they wonder how to cope with all the change taking place in their lives *and* their profession. We are going through a tremendous change in education today, from the *old* world to the *new* world. Within this major paradigm shift, in the old world for example, information was very linear; it just came from one source. In the new world, we have random access to many resources (e.g., Internet). In the old world, the lecture delivery system was basically the only delivery system available. In the new world educators discuss cooperative learning, learning "communities," and learning colleges. In the new world, in the changing world, we are looking at inclusive education, encouraging students to become accountable for their *own* behavior in the learning process. Additionally, the teacher's role is changing from the traditional information giver to evaluator, motivator, remediator, facilitator, and coach. For teachers who find the lectern the "buoy" that keeps them "afloat" in the classroom, all these new concepts seem like nonsense, a waste of time, and just one more "fad" to contend with.

"The only person who likes change is a wet baby."

—Roy Z-M Blitzer

FRAMEWORK FOR MI IN THE CLASSROOM

The following highlights the best and most effective strategies and provides examples of the learning options from the GCC pilot project. I share these with you as an example of what "works" for me. If you discover something of value for your teaching that ultimately benefits learners, USE IT!

I don't claim to have all the answers to the challenge of teaching today's learner. What I share with you comes from the heart of an experienced teacher willing to take a risk, look at

learning in a different way, and invite learners to "unlock" and discover a genuine joy of learning.

"If you always do what you always did, you'll always get what you always got."

—Verne Hill

This book is not intended as a kit to be duplicated, but as a practical tool for teachers, administrators, trainers, and others to add to their repertoire of resources and strategies for engaging learners in meaningful and lasting learning experiences. Therefore, rather than offering answers, this book provides a framework and examples to help teachers, trainers, and learners with specific examples of curriculum pieces and classroom instruction that can be used in day-to-day practice. Teaching is hard work. There are no recipes for success. The interaction with learners can be magical, or it can be disastrous. Nevertheless, I am reminded of a poster hanging in my office, given to me by a teaching mentor many years ago, that clearly explains why many of us—teachers, professors, trainers, facilitators—chose and remain in the profession we love:

"All teaching is an invitation to one of the most intimate human experiences: the touching of minds. Whether the contact is Jolting, Reassuring, or Revolting, it is almost always Intimate."

—Marshall W. Gregory

An Opportunity to Connect

Good teachers possess a capacity for connectedness. Despite this, we teachers spend so much time alone, preparing, reading, studying, and keeping current in our field. If what I have to say in sharing what "works" for me as a teacher strikes a chord in you, I encourage you to take the time and discuss it with a fellow colleague, whether that be a fellow teacher, administrator, manager, or parent. Effective change and reform comes about by honest and sometimes gut-wrenching and much needed dialogue.

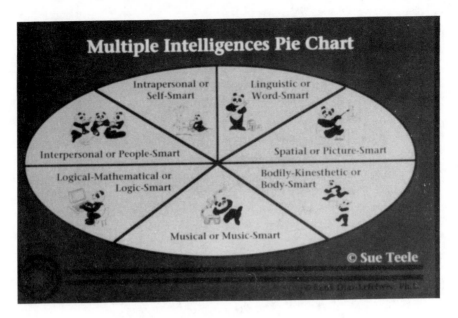

Intelligence Assessment

One of the components incorporated into the pilot study intro-
ductory psychology curriculum was the administration of a
multiple intelligences pictorial inventory. There are several MI
tests available. The two I would consider using are the MIDAS
(The Multiple Intelligence Developmental Assessment Scales),
developed by C. Brandon Shearer, and the TIMI (Teele
Inventory of Multiple Intelligences), developed by Sue Teele.
Let me be very clear about these two or other forms of assess-
ment for multiple intelligences. Both the TIMI and the MIDAS
cannot tell you what your intellectual strengths are. The TIMI is
strictly a measure of PREFERENCE. Which mode do students
THINK they are using? The MIDAS, which is a more seriously
developed instrument, attempts to INFER intelligences from
people's descriptions of activities that they like and are good at.
Actual measurement of intellectual performance can only be
determined by an outside examiner who has ways of assessing
how well a person USES each intelligence. This is actually the
only way we can tell what a student's profile of intelligence is.
There is no assessment tool on the market that is going to be
100 percent accurate. Whatever instrument is used, results
should be viewed as useful information for appraisal, elabora-
tion, and personalized learning strategies and options.

Teele Inventory of Multiple Intelligences (TIMI)

⇨ Test consists of 28 choices of A or B which picture TIMI bears in various activities

⇨ Responses are then calculated to reveal totals in the seven intelligences

⇨ Top four totals determine dominant intelligences

I give the TIMI pictorial inventory because it is simple and quick to administer and score. This inventory, designed for children (I have given it to over 1200 college students), consists of 28 A or B picture choices. In the pictures, panda bears perform various activities which depict the intelligences. Student responses are calculated and scored to reveal totals in seven intelligences (the eighth intelligence, the naturalist, has yet to be included in the inventory). The top four totals suggest dominant, or preferred, intelligences. It takes approximately half an hour to administer and score the inventory. Students have *fun* taking the TIMI and discussing the results.

Administration of the TIMI is given the first day of class. We do a good job identifying the academic readiness of students by testing them in reading, writing, and math. I believe we need to go a step further and assess students in the different ways they are smart. I am interested in assisting learners in identifying—even before they begin studying content—which of their intelligences are "leading the parade," and which ones are following. The following reflects the scores of the 131 students in the pilot study:

Bodily-Kinesthetic	27%
Interpersonal	24%
Spatial	16%
Intrapersonal	11%
Linguistic	08%

MI Assessment (1994-96)

TIMI Results (Pilot Group)

Linguistic	8%
Logical/Mathematical	8%
Musical	6%
Spatial	16%
Intrapersonal	11%
Bodily/Kinesthetic	27%
Interpersonal	24%

Logical-Mathematical	08%
Musical	06%

Bodily-kinesthetic was selected as the top choice by 30 percent of the 18–21 year-olds, 32 percent by the 22–30 year-olds, and 12 percent by the 30+ year-olds. The second highest selection was interpersonal: 24 percent by the 18–21 year-olds, 19 percent by the 22–30 year-olds, and 29 percent by the 30+ year-olds. Interesting enough, the two traditional intelligences, linguistic and logical-mathematical, did not score highly. Linguistic intelligence was selected as the top choice by 5 percent of the 18–21 year-olds, by 3 percent of the 22–30 year-olds, and 19 percent by the 30+ year-olds. Logical-mathematical intelligence was selected as the top choice by 7 percent of the 18–21 year-olds, by 7 percent of the 22–30 year-olds, and 15 percent by the 30+ year-olds.

The scores raise some interesting questions. How do students learn? Are we, as educators, making gross assumptions in how we think students learn? Perhaps not everyone learns academic material through technology and computers. Is paper/pencil testing and the lecture delivery system the BEST way to prepare learners in the 21st century? Is collaborative learning, small group interaction, and dialogue more compatible with many adolescent and young adult learning schemas? What part does developmental and social psychology (i.e.,

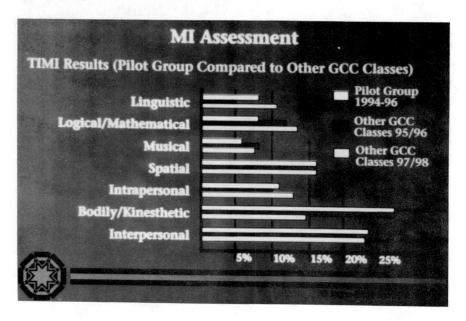

puberty, peer group pressure, and the need to be entertained) play in learning?

As the testing suggests, bodily-kinesthetic, interpersonal, and spatial intelligences "lead the parade" of dominant or preferred intelligences. The data strongly suggest a significant number of today's community college students prefer more action-oriented activities, with opportunities to move and act ideas out. Could community-service-type activities that are built into the academic curriculum assist these different types of learners? What are the implications for other "hands-on" learning activities like interviews, dance, mime, storytelling, or charades? As mentioned earlier, social scientists indicate that learning does not take place in a vacuum, but through social interaction, and research shows that the brain needs a stimulating environment to thrive and "grow" dendrites.

Course Outline

After administering the TIMI, I present students with the course syllabus. As you will see, it is a combination of traditional and non-traditional elements that I believe need to appear in a course outline. I include it only as an example. Be creative and imaginative and create your own!

PSY101 **Introduction to Psychology** **3 Credits**

Glendale Community College

Hi!

Welcome to the exciting and fascinating world of psychology. This class may be *different* than any other college level class you've taken because

"It's Not How Smart You Are; It's How You're Smart."

Just as choices and options are part of real life, you will be presented with various learning options to learn the content of this introductory psychology class. These choices/options are based on your different intelligences. In addition to exploring the nature and scope of psychology, we will look at the scientific nature of psychology, the process of learning and conditioning, memory, the brain and the nervous system, personality theories, psychological disorders and their treatment, the emotional basis of behavior, and social psychology. New information and research on the brain, multiple intelligences, development of the individual, and social interactions is constantly taking place. It truly is an exciting time to be studying psychology!

Learning/Teaching Styles

I view the teaching/learning experience as a highly **interactive process**. The first few class sessions will be devoted to assisting you in becoming aware of some potential learning styles that might help you **succeed** in our class. In addition to traditional paper/pencil testing, you will be given a variety of options to select from in learning the material presented.

My role as a teacher will be a combination of the following:

- A. Teacher/Information Giver
- B. Motivator
- C. Evaluator/Remediator and Resource
- D. Facilitator/Coach

Therefore, just as there are many different learning styles, I will utilize a variety of teaching styles. Hopefully, there will be enough learning activities in class and outside of class to maximize your learning of psychology.

I think you'll find the required textbook, <u>Psychology</u> by Philip G. Zimbardo and Ann L. Weber interesting and well written. In addition, <u>Psychology 95/96, Annual Editions</u>, is on reserve in the library for your use.

Our class meets 16 weeks during the semester. Because of the amount of information to be covered and the different ways it will be introduced, I strongly encourage you to attend every class session. I don't want you to miss out on anything!

I invite you to stop by my office, LS 165, Monday, Wednesday, and Friday, 11-12 pm; Tuesday and Thursday, 3-4 pm during my office hours or give me a call to make other arrangements. My phone number is 435-3736.

I look forward to our creation of an exciting learning environment as we study the fascinating world of psychology.

It's a pleasure having you in class!

René Díaz-Lefebvre, Ph.D.
Professor of Psychology

Standards of Excellence

1. Attendance Policy

 Family emergencies, job or health related issues sometimes prevent students from attending class. This is understandable. That's real life. Four absences (4) will be allowed before a drop is issued. I strongly suggest you be **selective** in the four absences allowed before a drop occurs.

2. Arriving Late; Leaving Early

 Please don't do this unless you've checked with me prior. It's called common courtesy!

3. Taping of Class Sessions

 I don't allow any audio/visual taping of my class sessions by students unless there is a special need. In that case, accommodations will be made.

Learning Options/Choices

4. The following learning experiences are available for you to select from as we journey through our study of the psychological human being. These learning options are based on *your* different intelligences! These "homework" options will be due weekly or at the end of the semester.

1.	Article Reviews (Verbal/Linguistic)	75 pts (Maximum 3 @ 25 pts ea)
2.	Computer Applications (Logical/Mathematical)	75 pts (Maximum 3 @ 25 pts ea)
3.	Chapter Collages (Visual/Spatial/Imagination)	150 pts (Maximum 3 @ 50 pts ea)
4.	Creative Dance (Bodily/Kinesthetic)	100 pts
5.	Video Reviews (Visual/Spatial)	75 pts (Maximum 3 @ 25 pts ea)
6.	Role-Playing/Acting (Bodily/Kinesthetic)	100 pts

7. Paper/Pencil Tests 160 pts (8 @ 20 pts ea)
 (Verbal/Linguistic)

8. Applied Term Paper 75 pts
 (Verbal/Linguistic)

9. Drawing/Sketching/Painting 50 pts
 (Visual/Spatial/Imagination)

10. Interview 50 pts
 (Bodily/Kinesthetic)

11. Book Report 50 pts
 (Verbal/Linguistic)

12. Journal Writing 65 pts
 (Verbal/Linguistic/Intrapersonal)

13. Sculpture 50 pts
 (Visual/Spatial/Imagination)

14. Musical/Rhythmic Application 100 pts
 (Rap, Musical composition, etc.)

15. Poetry 50 pts (Maximum 2 @ 25 pts ea)
 (Verbal/Linguistic/Speaking)

5. Grading/Evaluation

 Points Earned: 500 - 600 pts = A
 400 - 499 = B
 300 - 399 = C
 200 - 299 = D
 Below 200 = F

PSY101	**Course Outline** (We will attempt to follow the outline)
Part A	**The Diversity of Human Abilities, Memory, Multiple Intelligences, Learning, Brain and Nervous System**
Week 1	Course Overview, Learning Styles Inventories
Week 2	Ch. 11, Measuring and Explaining Human Diversity
Week 3	Ch. 7, Cognitive Processes (Memory, pp. 231-237, pp. 258 - 274)
Week 4	Test #1 (Ch. 11, 7) Ch. 6, Learning
Week 5	Ch. 2, Biopsychology (The Brain & The Nervous System)
Week 6	Test #2 (Ch. 6, 2) Ch. 8, Motivation (pp. 282 - 286, 293 - 316)
Part B	**Development of the Individual**
Week 7	Test #3 (Ch. 8, Motivation)
Week 8	Ch. 10, Personality
Week 9	Ch. 4, Psychological Development (Childhood, pp. 99 - 124)
Week 10	Ch. 4, Psychological Development (Adolescence & Adulthood, pp. 124 - 141)
Week 11	Test #4 (Ch. 10, 4) Ch. 12, Social Psychology
Part C	**Mind/Body Connection**
Week 12	Test #5 (Ch. 12) Ch. 3, States of Mind
Week 13	Ch. 8, Emotion (pp. 286-293, 317-324) Test #6 (Ch. 3, 8)
Part D	**Disorders and Treatment: What Happens When Something Breaks Down**
Week 14	Ch. 13, Psychopathology
Week 15	Ch. 14, Psychotherapies Test #7 (Ch. 13, 14)
Part E	**Taking Psychology With You!**
	Ch. 1, Mind, Behavior, and Science
Week 16	Test #8 (Ch. 1)

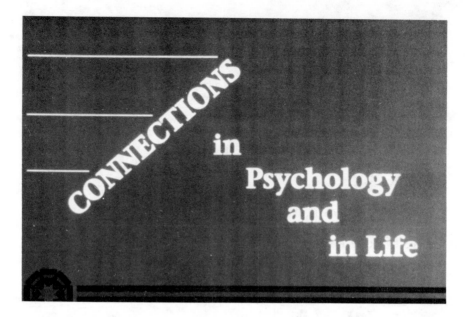

Learning Options Grounded in Academic Content

In addition to assessing students for multiple intelligences, the pilot study included a selection of learning options designed to compliment the various intelligences. In the pilot study learners were given 24 different learning options to select from. Each semester I rotate and provide different learning options among the original 24.

Creating the learning options is fun. It gives me the opportunity to work with colleagues in theater arts, English, dance, art, and music, who provide invaluable insight and guidance in the creation of student projects.

"Encourage every student to have an open mind. Then, something worthwhile may drop into it."

—Anonymous

Imagine the following scenario: It's the first class session, and students have just completed the TIMI inventory. I say to them, "Just as choices and options are part of real life, you will choose from a selection of learning options designed to complement your different intelligences and assist you in successfully

completing course objectives." Well, I want you to visualize the expressions on their faces. Just by the looks, I am sure they are thinking, "Is this guy for real? He's going to give us options to choose from? What about tests, term papers, lectures, all those things we are used to and comfortable with? Is it too late to drop this class? I want my money back! Must be some kind of weird psychologist going off the deep end!" These reactions occur many times. As I share my philosophy of teaching and learning, I tell students I am not interested in how smart they are, rather, I am interested in *how* they are smart. I go over a mostly traditional syllabus—an outline on what is to be covered, test dates (yes, I DO give tests!), homework assignments, and the evaluation and grading policy. Perhaps, what makes the course unusual and different for many students are the many choices they have in learning and understanding the course material. With choices and options comes responsibility and consequences of behavior. This sounds like a novel idea to some students, if not down right scary to most. I assure learners we are taking some risks together.

Challenging Students to Find Meaning in Reading

One of the biggest frustrations and challenges for any teacher is encouraging and motivating students to read the textbook assignments for understanding. I don't know how many times over the years I have felt so discouraged because of my students' lack of interest in reading—let alone understanding—the course material I was covering in class. I know I am not alone in this dilemma. This problem exists at all levels in education.

I have incorporated the following strategy as part of my new role as facilitator of learning. In my syllabus I set the tone for active involvement and participation by all learners. I emphasize the importance of READING the chapter. On the first day of class, prior to assigning homework, I pass out and go over the following:

Guidelines on Reading Assignments

Each learner be prepared to discuss:

1. One or two items from the chapter/assigned reading that seems *important* to you.
2. Parts of the chapter/assigned reading you think we should *review* or go *over*.
3. Items in the chapter/assigned reading that *surprised* you.

4. Topics in the chapter/assigned reading YOU can *apply* to your own *experience.*

I further explain, "Your opinions, ideas, and understanding of the chapter are important in your learning, application, and connection of key terms, themes, and concepts. I will add to your list of items information I believe is important to know and understand about psychology. Much of our class discussion will be based on a combination of your interest in different parts of the chapter and my coverage of the parts of the chapter I believe to be important in the study of psychology."

Arranging students into small discussion groups (3 or 4 in a group works great) gives learners an opportunity to discuss amongst themselves their answers to the assigned questions. Groups can be arranged in many different ways—by gender, ethnicity, age, etc. I usually try for a good mix of learners for more dynamic interpersonal discussions. After 5 or 10 minutes, I ask each group to share with the entire class the answers to their questions. As each student in the group identifies an area of interest, I ask him/her to identify where in the chapter this information is located. Once the student locates the area of interest (or confusion) in the chapter, I invite him/her to tell us his/her understanding of the material. As I listen to him/her explain his/her interest, surprise, or understanding of what he/she has read, I ask the rest of the class if they would like to add to the discussion. Often students find the same topics interesting or confusing.

"The great end of education is to discipline rather than to furnish the mind; to train it to the use of its own powers, rather than fill it with the accumulation of others."

—Tryon Edwards

Once students have shared their interest in the chapter, I use this valuable information as a preview of what will be highlighted in the class session. By inviting students to become responsible, interested, and *accountable* for their reading and learning, the teacher is able to focus on the rich and invigorating discussions that will occur. Because this exercise is an integral component of the class, my students know that if they don't read the assigned material, they won't be able to participate or keep up with the rest of the class. Successful under-

"You have to turn them manually, Vincent."

standing and completion of the course depends on how well the learner keeps up with weekly reading assignments.

Beyond the Scantron: Encouraging Understanding

Research conducted by cognitive scientists over the past few years has provided some uneasy, if not embarrassing, results: most students in the United States don't understand the materials presented to them in class. According to Howard Gardner, a leading proponent of education for understanding, when students are confronted with an unfamiliar situation outside of school, they generally are unable to mobilize the appropriate concepts from school, even if they have been good students. As an example, Gardner talks about the "smoking gun" effect that occurs in physics: students who have received high grades in physics at reputable institutions like MIT or Johns Hopkins are not able to apply their classroom knowledge to the real world outside of college. There are also examples from other disciplines. Students appear to understand the course material because they perform well on tests based on rote memory skills. Many students, completing this form of information processing, forget the material! Once out on their own, where they are

expected to apply school-learned concepts, facts, or skills to a new situation, they show they are incapable of understanding. According to Gardner, understanding is when an individual is able to *apply* knowledge, concepts, or skills acquired in some kind of an educational setting to a *new* instance or situation, where that knowledge is in fact relevant. Gardner (1991) says:

> Most schools are content to accept performances which are rote, ritualized, or conventionalized: that is, performances which in some way merely repeat or give back what the teacher modeled. However, at least in our current cultural context, and with our current value systems, educators ought to embody a more ambitious goal: the production of education for understanding. In such education, individuals do not merely spew back what they have been taught; rather they use the concepts and skills acquired in school to illuminate new and unfamiliar problems or to carry out fresh projects, in the process revealing that they have understood, and not merely imitated, the teachings to which they have been exposed. (p. 38)

Choices and Options for Success Gardner refers to the four "enemies" of understanding as short-answer assessment, the text-test context, the correct-answer compromise and the pressures for coverage. When I think back over my 20+ years of teaching, I wonder how many students fell "between the cracks" because of my insistence and belief in paper and pencil assessment as the most accurate way to determine student learning.

"The highest form of human energy is imagination."

—David Meier

MULTIPLE ENTRY POINTS

Real life provides us with choices and options for decision making. Why shouldn't schools at all levels reflect this kind of thinking? This is how my idea about incorporating a theory (MI) initially created for children came about. What would happen if I developed and taught a college-level class that identified, acknowledged, and encouraged different ways of being

smart? In addition, what would happen if I provided students learning options and choices utilizing their different intelligences through performance for understanding experiences? In other words, learners could select from a variety of MI/LfU learning options and incorporate a variety of domains.

A domain is a body of knowledge or human achievement (e.g., music, mathematics, writing, drawing, science). The theory of multiple intelligences claims that human beings have evolved at least eight different forms of knowing or processing information. An example of this notion is to imagine a house full of knowledge (topics, themes, ideas, concepts) that is accessible only through the front door (short-answer assessment, the correct-answer compromise, testing, testing, testing!) because the back door and windows are always "locked." By providing learners multiple entry (many doors and windows), *students* will choose which entry point is most appropriate for themselves. Once students become aware of and comfortable with the entry point(s) most suitable for them, they can be encouraged to "stretch" their thinking, application, and understanding and explore other entry points into the house. Hence, they have the opportunity to explore the multiplicity of intelligences that we all possess. Since understanding involves the ability to approach a concept or skill from a number of different angles, the learning option concept offers many routes to master, apply, and understand material across many domains.

"The next best thing to knowing something is knowing where to find it."

—Samuel Johnson

The multiple intelligences learning options were designed to provide learners with a strong, academically grounded method of incorporating key terms, concepts, ideas, themes, and topics from textbook readings, class discussions, or by other means deemed appropriate by the teacher or trainer.

Teacher as Content Expert

To be an effective teacher utilizing the MI/LfU approach, I believe the teacher or trainer has to have knowledge and feel confident about the discipline and pedagogy, or what is sometimes called "pedagogical content knowledge." The teacher is

the ultimate content expert. It is important he/she possess a high level of competence and confidence in the subject area.

One of the major causes of stress for many teachers (including college teaching) is the time-honored belief that we have to cover *everything* in the textbook or curriculum before students leave our classes. I have finally come to terms with this erroneous and impractical concept. I now attempt to *uncover* topics, issues, and areas that help me focus on what I am teaching and more importantly, *why* I am teaching it. I resist the compulsion to touch on everything in the textbook or the syllabus just because it's there, and instead I try to empower learners to become accountable for their own learning and behavior. I have come to the conclusion that *less* is *more*. In addition, I have had to think and rethink what is worth knowing in my discipline. I have been challenged to encourage learners to use critical thinking skills that honor a belief system that values reflective practices such as problem solving, analysis of data, creativity, and alternative solutions to problems. In essence, I have returned to the very core of why I became a teacher: to have the opportunity to challenge, guide, and influence the minds of the people I come in contact with.

"If you have confidence in yourself, you'll inspire confidence in your students."

—Anonymous

WHAT'S WORTH KNOWING

What's worth knowing about the field of psychology? Specifically, what is worth knowing in introductory psychology? Wow! Even for a veteran teacher like myself, answering this question proved to be a very challenging and rewarding undertaking. One of my first efforts was to search for any articles that could assist me with psychological literacy. I was interested in knowing which terms and concepts are considered significant and within the general knowledge base of the psychological community. In other words, I looked for what's worth knowing in psychology! Realizing that much of the public perception of psychology is based on "junk" psychology, such as that deliv-

ered by the notorious TV and radio talk-show hosts, I wanted to present psychology as the science that it is.

"Throw out the busy work and get down to the business of learning."

—Anonymous

In addition to reviewing the literature to find out what key concepts were considered important to know in the field of psychology, I also reviewed many introductory textbooks. I came up with concept-based learning options designed to encourage the development of projects. Concept-based learning for understanding encourages the learner to think beyond facts, to see patterns and connections between critical content and transferable knowledge. In presenting this method of higher order thinking, learners are challenged to "stretch" their minds to analyze, synthesize, evaluate, and reflect upon what they have learned. Therefore, the Multiple Intelligences/Learning for Understanding projects require self-directed learning, synthesis of information, in-depth analysis, problem solving, and persistence.

CHAPTER FIVE

What If . . . Applying MI, Creativity, and Learning for Understanding

WHAT IS CREATIVITY?

Creativity, like intelligence, is something everyone possesses. But what is creativity? A dictionary definition of "creative" states:

> Marked by the ability or power to create—to bring into existence, to invest with a new form, to produce through imaginative skill, to make or bring into existence something new

(*Webster's Ninth New Collegiate Dictionary*, 1983, p. 304)

I find the psychological literature on creativity unclear and confusing. Much that is written on the subject of creativity has little to do with real-life application. Psychologists generally agree that to be creative one needs to generate ideas that are relatively novel, appropriate, and of high quality. I will add to the definition of creativity based on my experiences with implementing multiple intelligences in learning for understanding. Students—hundreds of them—have also helped me formulate these ideas. Taking the time to listen to students has given me invaluable insight on the process of being creative.

"A lot of people joke that they learn something and when they take the test all the knowledge escapes through their pen."

—Linda, 27

The Creative Person

My notion of creativity is not based on empirical findings or some psychological study. It is based on *common sense.*

A creative person:

1. Takes chances and sensible risks. Asks "what if?" as opposed to saying "it can't be done!" (or I can't do it!).
2. Is persistent. Doesn't give up on his ideas even if others disagree and pressure him to conform.
3. Is open to new experiences and willing to "color outside the lines."
4. Has a willingness to grow and discover hidden talents. Lets go of the fear of failing and realizes learning is a moment by moment experience.
5. Believes in himself. Is tenacious and doesn't take no for an answer!
6. Has high standards and experiences a sense of personal satisfaction upon completion of creative work.
7. Believes learning is and should be fun.

Most schools, colleges, and other formalized learning environments discourage risk taking. Too often creativity is suppressed and students end up taking the "safe" courses while developing the attitude, "get the grade, then get the hell out." Unfortunately these classes reward and promote passivity.

"Creativity is so delicate a flower that praise tends to make it bloom, while discouragement often nips it in the bud. Any of us will put out more and better ideas if our efforts are appreciated."

—Alex F. Osborn

Passive learning is what takes place in many college and business learning environments. That is, information passes from the notes of the professor or trainer into the notebooks of the students without passing through the minds of either.

PERFORMANCE OF UNDERSTANDING

The big dilemma for many teachers is *depth* of understanding versus curriculum *coverage.* It is one thing to offer learners a variety of ways to learn material and earn points for grades;

however, without strong academic grounding and a direct connection to content, these types of exercises can become vague, meaningless drudgery. With this in mind, I developed learning options to complement my students' understanding of the chapters in the textbook and class discussions. These learning options include performances of understanding such as reciting a poem, explaining a collage, or performing a creative dance. I expect students to explain, give examples, generalize, apply, and represent themes, concepts, or topics in new ways. The learning options encourage learners to go beyond what they already know and to demonstrate this new way of learning academic material in front of their peers and the instructor.

Limitations of Testing

My experience with testing, especially multiple-choice testing, perhaps one of the most popular and most used forms of assessment by college teachers, is probably the *least* most effective form of assessing what a person knows and, more importantly, what a person understands. This type of test is most appropriate for declarative knowledge—the kind that students cram into short-term memory and quickly forget after the test. In addition, this type of assessment relies on the individual's ability to *recognize* previous stimuli that have been read or seen. Furthermore, the other type of memory strategy that is used quite often in testing is *recall.* This is simply a process in which a student memorizes verbatim facts or figures and is expected to reproduce the information at a later time while taking the test. Most teachers were great memorizers in college, yet if you were to ask them what they remember today from all the information they memorized, the honest ones would say it was a waste of time and certainly not something that has made any real significance in how they analyze and solve daily challenges and problems. Performances of understanding take time. Allowing learners time to think about, create, and execute their ideas is a crucial component of the curriculum planning process.

"Teaching for tests creates learnoids."

—Alan Scott Winston

If the learner has successfully prepared, demonstrated and explained an understanding of concepts, themes, or topics, this

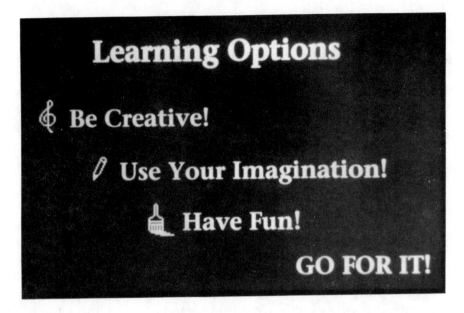

mini-expert can actually assist the instructor or trainer as a co-facilitator in class discussions. I have experienced students teaching each other many times over the last five years. On a few occasions student presentations have gone beyond what I expected of them, and the material was presented as well as or even better than I could have done! Why? Because the learning *belonged* to the students. They put forth the effort to learn, understand, and apply knowledge.

"Imagination is more important than knowledge."

—Albert Einstein

To successfully complete the learning options (sometimes referred to as "homework assignments"), students begin by using a very traditional intelligence—linguistic, or word smart. They have to read and understand key terms, concepts, ideas, topics, and themes from each chapter. The students then demonstrate what they are learning from the chapter reading and class discussions through the learning options.

Concept-Based Learning The purpose of the learning options is to provide students guidance and opportunity for

learning material in a different way. By learning course content in a variety of ways, individual differences, strengths, and weaknesses are acknowledged and utilized. Learners are encouraged to transfer thinking skills to real-life situations. Multiple intelligences learning options are developed with the following premises:

a. Not all students learn or understand material in the same way. However, for many, paper and pencil testing is the only method used in assessing how they are "smart."

b. The teacher is the content expert—the "keeper of the gate" with respect to making decisions about which terms, concepts, topics, themes, and ideas they want students to know. Contrary to popular belief, most students—young and older alike—prefer guidance and a format to follow in completing assignments. Results from the pilot study indicate students want, need, and appreciate knowing exactly what is expected of them and where they can find the resources (e.g., chapter textbook, library, computer lab).

c. The purpose of the learning options is to provide choices and creative options that accentuate the intelligences. Creativity and use of one's imagination is highly encouraged and, yes, rewarded!

d. The learner has an opportunity to become a mini-expert by performing or demonstrating an understanding of the material studied and applied.

e. The written and reflective component is an integral part of the student's learning experience.

f. The learning option provides an opportunity to reinforce whatever material the teacher or trainer is attempting to cover in class. For example, the same terms, concepts, and topics used in the "test" are integrated into options.

g. The learning options are intended to challenge students to have fun, be creative, get out of their "comfort zones," and apply learning to the real world.

h. The learning options require self-directed learning, synthesis of information, in-depth analysis, and persistence. This is a way to encourage learners to think beyond the facts and at higher levels than they do with instruction that is topically based.

i. The goal of the learning option is to encourage learners to see patterns and connections between critical content and transferable knowledge.

j. The learning option is a challenging project that is assessed by a MI/LfU creative grading rubric. The rubric assesses creativity/imagination, performance/demonstration of understanding, organization/format, communication skills, and reflective intelligence ("thinking about thinking"). Criteria for quality work should not be a mystery to students. Learners need to see the grading schemes and rubric that will be used to evaluate performance.

k. The primary purpose of the grading rubric is to provide feedback that is as accurate and precise as possible, so that students can improve their achievement.

"We are witnessing a virtual explosion in knowledge about human learning."

—Ted Marchese, American Association of Higher Education

THE LEARNING OPTIONS

Twenty-four learning options, designed to compliment the multiplicity of intelligences, were field-tested in the initial MI/LfU pilot project. The following is a list of the original learning options titles:

1. Sculpture (bodily-kinesthetic/spatial/intrapersonal)
2. Poetry (linguistic/imagination/intrapersonal)
3. Video Review (spatial/intra)
4. Journal Writing (linguistic/intra)
5. Charades (linguistic/bodily/imagination)
6. Computer Application (linguistic/logical/intra)
7. Chapter Collage (spatial/logical/bodily/intra)
8. Oral presentation (linguistic/intra)
9. Video project (spatial/imagination/bodily)
10. Interview (linguistic/bodily/interpersonal)
11. Creative Dance (bodily/logical/imagination)
12. Oral Presentation-Dyad (linguistic/inter)

13. Drawing/Sketching/Painting (spatial/bodily/intra)
14. Applied Term Paper (linguistic/intra)
15. Mime (bodily/imagination/logical)
16. Experiment (linguistic/logical/bodily/intra)
17. Musical-Rhythmic Application/Appreciation (musical/bodily/intra)
18. Book Report (linguistic/intra)
19. Acting/Role-Playing (linguistic/bodily/imagination)
20. Independent Project (linguistic/bodily/intra)
21. Computer Simulation and Graphics (logical/spatial-imagination/intra)
22. Article Review (linguistic/intra)
23. Cooperative Learning Project—2/3 Learners (bodily/linguistic/inter)
24. Traditional Tests (linguistic/logical/intra)

"We learn 10% of what we read, 15% of what we hear and 80% of what we experience."

—Anonymous, New Horizons in Learning, 1997

The Assignment

The heart and soul of multiple intelligences learning options and learning for understanding, at any level, is the learners' reflection on, connection to, and evaluation and application of learned material. I require my students, in their own voices, to comment on *how* and *why* learning for understanding and becoming responsible for their own learning became part of their experience.

"Wonder rather than doubt is the root of knowledge."

—Abraham Joshua Heschel

Prior to students' reading and discussion of each of the text chapters covered in the course, I give them 10 to 15 major key terms, concepts or topics I believe important in an introductory psychology class. The terms and concepts are taken from a list

that appears at the end of each chapter or from previously selected class material. The learning options provide a method of demonstrating—in a very creative way—an area of individual strength.

In my instructions, I encourage learners to be CREATIVE, to use their IMAGINATION, and to have FUN while completing the assignment. They are expected to spend reflective time thinking about and answering, in a written response, usually three questions specific to their learning option. A minimum of 1-1/2 to 2 pages are required. In addition, learners must present their finished projects to the class and respond to questions from their classmates.

In the following section, I provide examples of eight learning options and samples of exemplary, domain-related student projects, including student responses and comments. The students' names have been changed for their privacy, but the experiences are real.

DEMONSTRATIONS OF UNDERSTANDING

Using basic guidelines developed by a colleague, Darlene Goto, in GCC's art department, students are encouraged to include texture, images, colors, shapes, and forms, in creating a sculpture.

> *"The world of reality has its limits; the world of imagination is boundless."*
>
> **—Jean-Jacques Rousseau**

Sculpture Learning Option

The learning option provided Joyce (age 19) the opportunity to create a unique "castle," utilizing concepts, terms, themes, etc. from the chapters on personality (Freud) and psychotherapy

(Psychoanalysis). The three sculpture-related questions and Joyce's written responses follow:

1. Identify and explain 4 to 6 [this number is determined by the individual instructor] concepts, terms, themes, topics, or visual themes you have included from the chapter in your artwork. Be aware of and comment on the texture, color, shape, form, and design incorporated into your work. Be specific; show examples, and be prepared to explain in class.

 The castle symbolizes the person. There are three levels that are all connected: the dungeon, entry level, and the top floor. The card of hearts symbolizes emotions dealing with psychotherapy and ego defense mechanisms. The diamond white bishop represents the superego's purity, morals, and well-learned societal behavior. The clover and black rook represents the id's destructive and primal instincts (notice the color of cards).

"The job of the artist is always to deepen the mystery."

—Francis Bacon

The jester tells them to free associate or just say out loud every and any thought that is on their minds. The jester finds out that the queen does not like sex because she was molested as a child by her father; the king is angry at his parents. Down the rope and into the conscious level you see the king confronting his parents—the authority figures he is angry with—on the way they raised him. He is in the process of catharsis which is believed to be good. The queen, on the other hand, is showing resistance or unwillingness to discuss the fact that she was sexually abused by her father. She is also angry at her mother for letting it happen. Down to the unconscious we have the dream analysis where the visible and latent dreams usually depict something of deeper thought than what is actually going on. The king's visible dream is where he wrestles and overcomes the challenge of the beast. The king is angry at his parents and the beast symbolizes his father after the king had confronted his parents for the first time about his anger. He then unconsciously transposes his feelings about his father towards the jester. Therefore, he experiences transference and starts chasing the jester up the rope. The queen's latent dream is the beast, her father, pushing her off the cliff. The beast has control of her because she refuses to acknowl-

edge her pain. Through working with the queen and the king, the jester becomes fond of the queen because he sees he can rescue her from her problems; therefore, he associates her with his ex-wife who shows the same characteristics. He countertransfers his feelings of his wife towards the queen, he proceeds to chase her up the rope. Sorry if this is confusing. Please allow me to give you a detailed explanation of the castle. It is very difficult to write about it without you being able to see it.

The kings of every suit and white queen are the ego breaking up the fight between the id and superego. From there you can go to the left to descend down the ego defense mechanisms to get to the conscious level of the psychosexual stages and then proceed to the dungeon of drives and instincts of the Thanatos (death, rage, aggression), libido (sensual pleasure, sex drive), and the Eros (survival of the fittest, self preservation). I believe that these instincts are primal and subconscious that are part of the id, ego, and superego. After all, the id is an unconscious force. Therefore, the spade or club represents digging deep beyond the surface, the club being what people use to defend themselves against others. The psychosexual stages are how we progress through life. Each entry level room from left to right, shows the psychosexual stages: oral (sucking, every object goes in the mouth), anal (potty training and anal fascination), phallic (discovering sexual anatomy), latency (beginning school and focusing on learning), and genital (puberty, develop-

ing relationships). Notice that near the door there is a trap door where the little girl could become fixated (inability to progress beyond that point) and fall into the drive and instincts level due to sexual abuse in the phallic stage where she is discovering herself (light bulb) and dealing with feelings towards opposite sex parent; therefore, she counteracts those feelings by identifying with the same sex parent who looks just like her (mirror image). Notice the cards tell the story of the different ages as we progress. In the genital stage the two pairs of hearts and the full house of hearts symbolize relationships and love. The ego defense mechanisms are connected to the psychoanalytic therapy, which descend from the superego on the right and to the dungeon as well. The top floor shows denial: the queen (with her close friends) refuses to acknowledge that her parents sexually abused her as a child. The jack of diamonds (superego) is angry at the black jack (id) so the jack of diamonds displaces his feelings and takes his anger out on the beast rather than the id as society would accept that. Going down to the conscious level I show the queen as isolation and the one-eyed jack as being passive aggressive, looking at the black jack and the queen together, and he wants to be with the queen. Therefore, he goes down to the dungeon (unconscious) and looks up at the ceiling and fantasizes about himself having sex with the queen. This daydream makes him angry; therefore, he regresses back up to the conscious level and pulls his safety rope up with him, so the fantasy can't irritate him anymore. The whole point of the ego defense mechanism is to reduce the anxiety of stress involved in a situation. The last part is the psychoanalytic therapy. The top level is the king and queen at opposite corners of the room having marital problems and the court jester is going to be the therapist, because in olden times the jester listened to all the king's problems.

"Play is the exultation of the possible."

—**Martin Buber**

2. How has this bodily-kinesthetic/spatial/intrapersonal experience assisted or reinforced your understanding of concepts, terms, topics discussed in class or mentioned in the textbook? Be specific and give examples with your explanation.

In order for me to put together the castle and all the symbolic representations of cards and chess, I had to study the chapters on person-

ality and psychotherapy. By making all the cards symbolic of people, emotions, and experiences, I have glued these concepts in my brain.

3. Provide a paragraph (or longer!) of reflection and evaluation of this sculpture experience. This learning option provided an opportunity to learn academic material in a different way. By completing the assignment in this way, was it beneficial in helping you LEARN and UNDERSTAND the material better? How and why? Be concise and specific.

I really enjoyed doing the sculpture and putting all the concepts together. I wanted to get a big picture of Freud's concepts and relate them to each other.

I can guarantee that the castle and its concepts will stay with me for life. It took A LOT OF TIME AND CREATIVITY TO BUILD. I wanted to be able to take something and put it together and also take it with me from psychology. I know Freud had a tremendous influence on psychology as well as many other areas, and I did not want to leave psychology and be illiterate to Freud's contributions. I can really see how his ideas on the unconscious, conscious, and subconscious come together to make up the whole person. Thank you again for challenging me to do this learning option.

In much depth and detail Joyce has demonstrated an understanding of the material she studied and depicted in her sculpture. Further examples of learners applying what they learned by creating a sculpture follow:

First I picked a topic, then I had to think really hard on how to represent it in a sculpture. I had a ton of different ideas, but my final idea incorporated all of my key terms and concepts. I am definitely going to remember these key terms because they are all I have had on my mind for the last couple of days.

(Frank, 18)

"Art? You just do it."

—Martin Ritt

This learning option (sculpture) really helped me better understand the chapter because it gave me a chance to physically put together something that I mentally understood. It let me produce something tangible to represent what I learned and remembered in my head. I

had to really know what drugs (chapter 5 on Consciousness) went into which categories and what each one did and where it came from. I think this learning option was very beneficial in helping me learn the material discussed in the book and in class. I also did a collage on this chapter, so between the two visual representations I think that I know this chapter very well. This gave me a way to express my creativity and still learn the information.

(Julie, 23)

To be honest with you, the main reason I chose to do this kind of sculpture was because I thought that it was going to be the easiest thing I could do, and up until last night I thought it was going to be a piece of cake . . . I actually had fun doing the sculpture once I figured out what I was going to do. It reinforced what I had read. I am really glad I was able to do these hands-on learning projects.

(Rolando, 18)

I made a brain out of wire and nails. I call it "Brain of Steel," and it symbolically represents the power of our mind. The cerebellum that coordinates muscle movements and balance is represented by these different types of wires . . . by doing this sculpture I had to observe the shape and parts of the brain. It took me a few days of work to make this sculpture . . . after I got done with the skeleton of the sculpture I started adding details. I had my book with the brain in front of me all the time, trying to make the perfect shape.

(Michelle, 27)

This sculpture (below) took more time than I thought it would. The reason why is because, when I started the sculpture, I had one

thought in mind, but the more I did the sculpture, I got other ideas that were equally effective. It took me about four or five different ideas before I settled on this one. While I was working, though, I had time to think of how I was going to present it and what each thing symbolized. This way, it was easier to answer the three questions, since I already knew what each subject meant.

(Reggie, 21)

Poetry Learning Option

"Poetry often enters through the window of irrelevance."

—M. C. Richards

The poetry learning option provided Maria (age 18) the opportunity to create a poem 13–15 stanzas long. She chose to create a poem from the chapter on personality. Maria's poem is on Freud's Id, Ego, and Superego. The three poem-related questions and Maria's written responses follow (Title: *Quarrel*):

1. Identify and explain 4 to 5 concepts, terms, themes, topics, or ideas you created and wrote about in your poem. Be aware of and comment on mood, rhythm, and emotion incorporated into your work. Be specific; show examples, and be prepared to explain in class.

 My poem, "Quarrel," creatively interprets the voices of the Superego, the Id, and the Ego. The first stanza is the Superego complaining about the Id. The next stanza is the Id antagonizing the Superego. Finally, the last stanza is the Ego urging his feuding brothers to realize their mistakes.

 The Superego loathes the Id's threat to his world. The Superego must constantly pick up after the Id's mess. "Trash the glass, then make it mold" is a line that can be interpreted in different ways; one would say the Superego must make the glass mold again after the Id ruins it. The Id lashes back to say the Superego has no courage and will never take the risk.

 The audience will note the Id will continue to entice Superego: "Do you know the extreme of numb?" The Ego steps in as a referee. He attempts to show them the big picture. The line: "Last this long–less than years," is saying "you've gotten this far but you won't last much longer."

Quarrel

Trash the glass, then make it mold
 You will not die yet, you are old
 Three alarms but you don't burn
 A gnash of teeth is what you yearn
 Tomorrow is just one more day
 You won't work and I'll not play

 Don't spit all your righteous do's
 I risk it all, I'll never lose
 You- so full of empty spine
 You can't walk my fine line
 Grab your blanket, taste you thumb
Do you know the extreme of numb?

 Tender moments lost in rage
 Naïve to your own classic cage
 You aren't right but never wrong
 Side step each point, the gap is too long
 Call to me for drying tears
 Last this long, less than years

I chose to print the poem with a visual aspect as well. The audience will see Superego's words clear to the left but sliding to the right. Id's words are displayed in an opposite format and looking a bit haphazardly. Ego's words are down the middle in a very compromising tone. This presentation builds upon the characteristics of the three positions.

2. How has this linguistic/imaginative/intrapersonal experience assisted or reinforced your understanding of concepts, terms, topics, discussed in class or mentioned in the textbook? Be specific and give examples with your explanation.

I will never forget these Freudian concepts after working on my poem. To be able to interpret the three characters correctly, I had to understand the ideas. However, the reinforcement and creative freedom of the project allows it to be more significant than words in a thick book. My poem has also sparked more concept realization and ideas for a different creative project. I do understand these three concepts to a stronger degree after being involved in this linguistic experience.

3. Provide a paragraph (or longer!) of reflection and evaluation of this poetry writing experience. This learning option provided an opportunity of learning academic material in a different way. By completing the assignment in this way, was it beneficial in helping you LEARN and UNDERSTAND the material better? How and why? Be concise and specific.

I love writing successful poetry. I am excited that I had the opportunity and motivation to get involved. I am very proud of the work I have done because it comes off as an abstract poem; however, it can be understood. I feel this is one of my better poems. The basic idea for this project was to learn. I can honestly say I have a much stronger hold on the concepts of Id, Ego, and Superego. This was one of the most enjoyable assignments I have had the opportunity to do throughout my entire education career.

"Every child is an artist. The problem is how to remain an artist once he grows up."

—Pablo Picasso

The following are further examples of how students used poetry as a means of learning academic material:

I think poetry is a wonderful idea for a learning option. It allows one to become greatly involved in the topic he or she plans to write about. Furthermore, one's creativity can overflow . . . and that the individual is able to express himself or herself knowing that she will not be graded as this is right and this is wrong . . . for it is that individual's opinion.

(Roland, 27)

Writing this poem helped me understand the concept of classical conditioning and the things that go along with it. In order to write creatively about this topic, I had to first understand the literal mean-

ing of all of the terms and ideas involved, such as the various experiments with conditioning that were described in the book. I had to make sure I understood what everything meant before I could look at the material abstractly enough to make a poem out of the information.

(Lateesha, 19)

In writing the poem I had to process the information creatively instead of just as facts out of the book. This gave me one more way to remember the information. Due to this I feel this chapter will stay with me for a long time.

(John, 23)

Musical Doctors

There lived a young boy named Xavier
His mother worried because of his abnormal behavior
She racked her brain, but couldn't figure out why
So she decided to give a psychologist a try
So that next Monday at 4:00pm
Xavier went and saw Dr. Timm
For 50 mins he listened in that office of teal
And concluded psychodynamic was the deal
Dr. Timm explained his sighting:
The ego, super ego, and id were fighting
Mom wasn't convinced with this 'personality coach'
So she took him to a psychologist with a humanistic approach
Dr. Rob listened to the boy long and hard
Doc said the problem was low self regard
Mom disagreed so next was Dr. Avrial
Who explained the problem was behavioral
Classical conditioning had occurred
According to what she had heard
With this diagnosis mom couldn't live
So next was a doctor who said it was cognitive
Distorted thinking explained what he did
Next! Dr. Sid.
A psychophysiological perspective ruled his activities
This was caused by nervous system abnormalities
Mother considered this doctor crazy too
Next a doctor was found with an eclectic view
This man considered himself one of the greatest 'detectives'
Basing his practice from multiple perspectives
Surprise, surprise, mom didn't agree
There wasn't a doctor that kid didn't see
Still there lives that young boy Xavier
No one has yet to figure out his abnormal behavior!

I incorporated many terms, concepts, and themes into my poem enti-
tled "Musical Doctors." First, I introduced the whole idea of abnormal
behavior. I didn't give a book definition or anything, just a tone . . . I
went on to describe the six explanations of abnormal behavior.
Writing this poem has really reinforced the concepts discussed in
class. Having to write the poem required me to fully understand all of
the meaning I incorporated in my writing. I had to look back at the
book definitions time and time again and finally it would click and I
could write a line. This was absolutely my favorite learning opportu-
nity so far!!! Honestly, I didn't want to write a poem. It was one of my
last choices, yet I actually enjoyed writing the poem. I though it was
going to be nothing but a burden, when it actually turned out to be a
blast. I can't wait to write another poem!!

(Shanna, 19)

Another example of a student poem appears on the next page.

Journal Writing Learning Option

*"Very early in life I became fascinated with the wonders language
can achieve."*

—Gwendolyn Brooks

The journal writing learning option provided Connie (age 22)
an opportunity to WRITE, WRITE, WRITE! The journal writing
offers an intellectual exercise in explaining one's own thoughts,
feelings, and ideas about what is read in the textbook, discussed
in class or learned outside of class. The journal provides learners
a less formal and less threatening way to write and express
themselves. Journal entries are to be made frequently, avoiding
long periods of delay. The learners are encouraged to monitor
what they are learning, reflect upon their learning, and write
about the experience. The following are sample writings from
the journals:

My favorite learning options were journal writing, collages, and surpris-
ingly, computer applications. Through this class I realized that I do have
many intelligences, more than I thought was possible for me. Thank
you for giving me the chance to get personal by writing in my journal.
The journal just has that affect on me. It makes me feel comfortable in
expressing myself about how I feel regarding a certain topic.

(journal entry, 2/9/96)

How I Learn

I learn like no one else
I listen like no one else
I take what I hear and process it
That which I do not need is discarded
That which I need is remembered forever
I will express my knowledge
In the ways in which I only can
To write a poem, draw a picture, or to speak orally
In my own special ways will I learn
To remember information is a talent to cherish
To give me information
And tell me to repeat it
Helps me not
For I have no use for that
My work is my work
No one else can do my work
This work is cherished
The work shows the individual that I am
It helps me to understand who I am
Where I am to go
What I need to survive
Only that which is needed to survive
Is what I learn
Give me the option
And I will be a better student
Tell me what to do I will fail
If I am to grow
Failing will not help
Only success of the path I have chosen
Give me the choice to choose a path
If I choose incorrectly I learn
If I choose correctly I learn
I am the one who has the choice to live a happy life
No choice, no happiness
Please give me the choice to learn
For then and only then will I succeed
This success will give me the smile I have waited for

Some further examples of how students used journal writing as a means of learning academic material:

"Words are a form of action, capable of influencing change."

—Ingrid Bengis

The journal writing gave me a chance to come home from school and remember what I learned that day. I love to write! Journal writing is a method of relaxation for me, and I am glad you gave me the opportunity to do it.

(Amy, 23)

By writing almost every single day helps me go back and look at what I have learned, because there are days that I forget what I learned . . . I am surprised with all the writing I did.

(Joseph, 27)

I decided to read all of my journal entries, and I hadn't realized that I learned so much this semester, not only academically but about myself too! I've learned that I'm actually more creative than I thought! At the beginning of my journal I wrote, 'What are my intelligences?' Well, I have learned that I am not just a "book smart" person; I was given the opportunity to shine in a different spotlight and it felt really great!

(Yolanda, 36)

This journal writing learning option has really helped me better understand the material discussed in class. I was able to jot down key points from class discussions and take time later to reflect and write about those points based on my thoughts, feelings, and opinions.

(Tyrone, 18)

I really feel that keeping this journal made what we were learning more real to me. The concepts became more than just words on a page as I tried to apply them to my life and personal growth. I think the biggest personal benefit for me was the feeling that what I write and how I think and learn things is important . . . I want to thank you for allowing me a safe environment in which to spread my wings!

(Candace, 29)

"During [these] periods of relaxation after concentrated intellectual activity, the intuitive mind seems to take over, and can produce the sudden clarifying insights which give so much joy and delight."

—Fritjol Caped, Physicist

Collage Learning Option

The collage learning option provided Ignacio (age 22) the opportunity to design a collage from information in the chapter on motivation. The three collage questions and Ignacio's responses follow:

1. Identify and explain 6 to 8 concepts, terms, themes, topics, or ideas you visually designed in your collage. Be specific; show examples, and be prepared to explain in class.

 I used a picture of someone standing on a cliff enjoying the view to show intrinsic motivation. Intrinsic motivation is an action based on individual reasons, such as satisfying curiosity. I used a picture of an anorexic girl to show the disorder of Anorexia Nervosa. This is a serious eating disorder that causes the person to under-eat due to distorted beliefs about being overweight.

2. How has this spatial/logical/bodily/intrapersonal experience assisted or reinforced your understanding of concepts, terms, topics, discussed in class or mentioned in the textbook? Be specific and give examples with your explanation.

 This experience has better helped me understand intrinsic and extrinsic motivation as discussed in class. This is because I now have visual pictures encoded with these principles. I also now have a better understanding of Henry Murray's Theory of Needs as discussed on page 327 in the textbook. I can now look back upon my experiences and have a better understanding of why I did certain actions.

3. Provide a paragraph (or longer!) of reflection and evaluation of this collage experience. This learning option provided an opportunity of learning academic material in a different way, was it beneficial in helping you LEARN and UNDERSTAND the material better? How and why? Be concise and specific.

 This experience has given me a better overall understanding of motivation and the things that affect it. By searching for pictures to complete the collage, I was challenged to think about key words and concepts in a more realistic way. The concepts were no longer just words on a page; they had become real life actions and events. Achievement was not just an eleven letter word; it had become a person who won the race and the person who received a degree. I think the biggest benefit though, was actually that I will remember

these terms longer because they are now associated with other terms that were previously unrelated.

"Art is a technique of communication. The image is the most complete technique of all communication."

—Claus Oldenburg

Further examples of learners applying what they learned by designing a collage:

> By using this method of learning, I have been challenged to study out of the usual norm. Until I attended this class, I dreaded my study time. Now, I actually enjoy my research and homework assignments. By challenging me out of my norm, I have found an approach to learning that is fun and interesting. I have spent three times as much time on these weekly assignments than I would in a common college class. However, since I am enjoying the process, I continue to spend more and more time with the learning options; thus I learn more than I could have ever imagined.

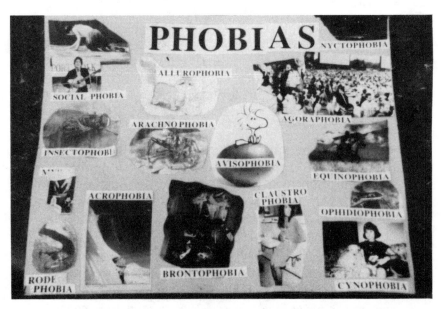

(Molly, 22)

After reading the chapter I feel I had a basic overall understanding of the information but I didn't really know it all that well. After doing this collage, I was able to put pictures and word phrases to the information in the textbook. Being able to see something in front of me

(like pictures from a magazine) really helps me to get a better understanding of what I am reading . . . in order to do the collage correctly you have to really understand the reading in the chapter.

(Jorge, 38)

I think this chapter collage was very successful. I started out with only a vague understanding of the chapter, and by the end of this learning option I understood even the smaller details of the chapter. This learning option was extremely beneficial because it let me actually "see" what I had been reading . . . I took what the book put into words and made them into pictures, that's how I understand and learn.

(Marsha, 23)

"The purpose of art is not a rarified, intellectual distillate—it is life, intensified, brilliant life."

—Alain Arias-Mission

Through this learning option the different terms and concepts were reinforced in a couple of different ways. One way occurred through the process of looking at different pictures and connecting what I saw on the paper to what was written in my book. It was necessary to sit down and think (even if it was abstractly) about where the terms and pictures fit together. For example, I used the road map to represent the central nervous system because the brain and the spinal cord really are the maps to our entire body.

(Roy, 42)

Making the collage has helped me understand the terms throughout the chapter more by having to understand the meaning of terms and having to find situations in which they occur . . . I feel that it helped out considerably in understanding because I had to read and re-read the definitions to be able to find pictures to express what I thought the definition was. [See next page.]

(Bernice, 20)

This collage was beneficial in helping me with Chapter 10. For one thing, it was fun. I really enjoyed doing the collage, and I felt creative in picking my own pictures, colors, and shapes. It really helps me learn the terms when I am able to associate them with a picture of my

choice. The whole process, looking through magazines, finding the picture, and then explaining the term, is what teaches me the term and its meaning in the "real world."

(Jimmy, 26)

By completing the assignments in this manner, students not only read the material, they are required to practice additional techniques out of the usual "norm." For example, when a person reads new material, in most cases, the information cannot be fully comprehended without some type of reinforcement. The collage provides reinforcement because it forces the student to dig deeper into the meaning of the concepts. The student must perform some kind of research in order to complete the project . . . Once the concepts are identified, the student searches for illustrations that will represent their meaning/definition . . . the process becomes a systematic approach to learning.

(Sylvia, 45)

Representing the concepts from the chapter in a visual way gives the concepts double impact in my memory because I remember the concept from reading it in the chapter, and I remember the concept from the picture I selected.

(Kevin, 28)

I realized that I use different types of thinking when I make a collage than when I'm reading and studying material for a test. By using these creative kinds of thought processes the project was not only more interesting but more memorable.

(Keila, 19)

This method also helped in learning the details of the chapter, in that to properly complete this assignment I found myself rehearsing the definitions of the concepts and terms while browsing the magazines and the Internet to find acceptable pictures.

(Maggie, 25)

Making a collage requires more thought that it appears to. You have to create a visually aesthetic piece of work. This activity forced me to stretch beyond my boundaries. Although I found it a challenge, I had fun with it!

(Francisco, 19)

I find chapter collages the most beneficial of all the learning options . . . for they challenge you to take what you read and apply it to instances in your life . . . this is true learning.

(Jean, 40)

Each concept was rehearsed in my mind while searching for pictures which I felt represented the idea. As I searched through the Internet

and magazines I found myself reading many additional articles about the concepts presented.

(Roger, 21)

"Make lessons interesting. You don't want to be known as one who talks in other people's sleep."

—Anonymous

Not only did I have to read the chapter to become familiar with the material, but I had to spend reflective time to really digest and mull over what it meant to me.

(Yvonne, 46)

I am extremely visual, and any time I have the chance to learn the material visually I take it. To be honest, I was dulled by parts of the chapter. I had to read and I needed to see what was on the pages. I took this chance to teach myself in a way that I would learn faster and the information would be a little more clear. I am creative, and when I get my creative juices flowing, I can produce great results.

(Jordan, 19)

I loved this learning option!!! I have a very active imagination and I love to use it. I liked looking for the pictures, cutting them out and pasting them. To the average people who look at my collage, they might see just some pictures clipped out from a magazine . . . but to me, I see so much more. I see art. I just couldn't pick just anything I saw to portray the concept or term; it had to jump out at me and say, "Wouldn't I be a perfect example of that concept?" That may sound crazy to you or others, but that is how I think. When I look at my collage, I also see a study guide.

(Sandy, 17)

"A mind, once stretched by a new idea, never regains its original dimensions."

—Oliver Wendell Holmes

Creative Dance Learning Option

The creative dance learning option provided Nicole (age 19) and two of her classmates the opportunity to choreograph and perform a dance utilizing concepts, themes, etc. from the chapter on psychopathology (Abnormal Psychology). They selected dissociative personality disorder, once known as multiple personality disorder, to create the dance. Nicole explained her part in the dance and fielded questions from classmates. She then performed the dance. Using basic guidelines developed by a colleague, Lenna DeMarco, in GCC's dance department, students are encouraged to explore space, energy, time, form, and intent/content in the dance.

1. Identify and explain 3 to 4 concepts, terms, visual themes, and physical movements included in your dance. Be aware of and comment on space, energy, and time. Be specific; show examples, and be prepared to explain in class.

 In the dance, Maggie is the original personality, while Peggy and I are the personalities that take over when the original personality cannot cope with a situation. Peggy is the sophisticated personality who goes to art shows, ballets, musicals, etc., and knows all the knowledge that would be expected. She also gives off a soft, glamorous appearance. I am the personality that is ready to go do anything wild. I take over Maggie's personality whenever she is too shy or weary of doing something new and exciting. When the music bares deeper

tones, I am in control. We start the dance all together in a flowerish pod. Maggie is standing in the middle while Peggy and I are on the sides. We did this because Maggie is the main personality, and we were born from her. Throughout the song the music varies. There are times when it is soft, sweet, and innocent sounding; this is when Maggie, the main personality, is in control. When the music is deep and harsh, I am in control; and when it is delicate and soft, Peggy is in control.

Not to confuse you, but the very first harsh deep notes are when we are coming out, it exemplifies the terror that has caused the main personality to need to alter personalities. There is also a time when both my music and Peggy's plays together, this can be seen as we are companions in conflict, or we are deciding who would be the more appropriate personality to take over for the situation. When Maggie's personality is out, Peggy and I dance, because as the alter personalities we are always aware of what is occurring. However, when Peggy or I are in control, Maggie freezes, because she has no clue. When Peggy is in control, I still dance, and vice versa, because we are there for the main character at all times.

"I shall dance all my life, I was born to dance, just for that."

—Josephine Baker

2. How has this bodily-kinesthetic/logical/imaginative experience assisted or reinforced your understanding of concepts, terms, topics, discussed in class or mentioned in the textbook? Be specific and give examples with your explanation.

Deciding exactly how things would work for a person with Multiple Personality Disorder is very fun but challenging, because we can only assume how it would be from what we have heard or read. The first time I heard the music I knew it would be perfect for MPD, but deciphering how to use it has been the confusing part. There are so many ways of interpreting how the music could exemplify an alter personality, or main personality. I have a lot of empathy for those people who suffer from such complex, dramatic lives. I know that it is hard just figuring out how to make up a dance to what people must live with every day. Doing this dance, along with the research, has given me an appreciation for my own life and a desire to learn all I can about people with personality disorders, not just MPD, so I can be a helpful individual in society by understanding the victims.

3. Provide a paragraph (or longer!) of reflection and evaluation of this dance experience. This learning option provided an opportunity of learning academic material in a different way. By completing the assignment in this way, was it beneficial in helping you LEARN and UNDERSTAND the material better? How and why? Be concise and specific.

> Doing this dance gave me a better understanding of the chapter, because I found myself trying to be a multiple personality, trying to be part of a unique dramatic illness. This chapter, to me, was already interesting, because I find such a strange illness fascinating. My interest level for this chapter was already heightened prior to thinking of ideas that could explain the disorder. I think that doing the dance explained to me the sadness and fear that a victim goes through. There is no way that I could ever confuse any aspect of MPD with another personality disorder such as schizophrenia. On top of the self knowledge and MPD knowledge I gained, I had fun.

The following are further examples of learners applying what they learned by choreographing and performing a creative dance:

> If I had not done the dance, I would have never watched the video or reread the material in the book. This learning option helped me in the fact that it challenged me to research the subject and think about the subject and create moves to express the ideas of the subject.
>
> (Janine, 18)

> Thinking of movements was not difficult, but applying them was. I really enjoyed using my imagination and emotions to do this learning option and to learn this information.
>
> (Cheryl, 25)

"Try? There is no try. There is only do or not do."

—Yoda, The Empire Strikes Back

Drawing/Sketching/Painting Learning Option

The drawing learning option provided JoAnne (age 25) the opportunity to draw a very creative "court of law" in reference to the chapter on personality. Specifically, she created a drawing on Freud's Id, Ego, and Superego. Using basic guidelines developed by a colleague, Darlene Goto, in GCC's art department, students are encouraged to include color, texture, design, balance, and form in the sculpture (Title: "Freudian Court of Law"):

1. Identify and explain 3 to 4 concepts, terms, themes, topics, or images you have included from the chapter in your artwork. Be aware of and comment on color, texture, design, balance, and form incorporated into your work. Be specific; show examples, and be prepared to explain in class.

 The Id is represented by the Tasmanian Devil. As you can see, he doesn't seem to care about anything else that is going on, and he seems to be causing a lot of trouble. Id is defined as the "Freudian personality structure that operates irrationally, impulsively, and selfishly" (Chapter 10; p. 383). The Superego is represented by Sir Jiminy Cricket. I have tried to depict him as admonishing Taz, just like a superego should, as defined in the text: "embodies society's values, standards, and morals" (p. 383). If you've ever seen Pinocchio, you'll know what I mean. The Ego is best represented by Barney, as far as

cartoon characters go, because Barney is always explaining things on his show. Plus, he is probably the only one big enough to control Id or Taz, just as the text says he should: "The ego is responsible for resolving conflict between the Superego and the Id" (p. 383). Therefore, I have put Barney, the Ego, on the judge's bench, so that he can mediate.

2. How has this spatial/bodily/intrapersonal experience assisted or reinforced your understanding of concepts, terms, topics, discussed in class or mentioned in the textbook? Be specific and give examples with your explanation.

 This experience has helped me learn the Freudian personality structures by forcing me to concentrate on each element one at a time and assign my own personal meaning to them. I assigned meaning by making each personality structure into a cartoon character.

 Before I could do that, however, I had to fully understand what the structures were and how they interacted with each other. More importantly, the drawing gave me a reason for learning the material. Before I did the drawing, the personality structures were a little bland; now they are quite colorful!

3. Provide a paragraph (or longer!) of reflection and evaluation of this spatial experience. This learning option provided an opportunity of learning academic material in a different way. By completing the assignment in this way, was it beneficial in helping you LEARN and UNDERSTAND the material better? How and why? Be concise and specific.

"For me a painting is like a story which stimulates the imagination and draws the mind into a place filled with expectation, excitement, wonder and pleasure."

—J. P. Hughston

In order to understand the role of each Freudian personality structure, I tried to associate it with a cartoon character. I began to realize that if this visualization was helpful, then putting it to paper might be even more helpful and fun. First, I picked my characters, which was fairly easy. The hard part was putting them in a scene together that would express their relationships to each other. This also proved the most beneficial. Putting these characters in a courtroom scene helps me understand the way they interact with each other. Jiminy,

the Superego and conscience, is like a prosecutor. Taz, the Id, is the defendant. Barney, the Ego, is the judge and mediator. This is actually more of a civil trial in which the judge hears both sides and presents a compromise. By putting these seemingly abstract concepts into a form that I can relate to, I can understand and remember them a little better.

Further examples of learners applying what they learned by drawing a picture follow:

The whole idea of the drawing is the concept of nature vs. nurture . . . I really was impressed with my ability to draw, and I enjoyed taking the time to work on the assignment. Once I created my opinion and put it on paper, I truly know what I was trying to grasp. [See picture on next page.]

(Linda, 20)

I think giving us the opportunity to draw pictures of the things we learned is a wonderful type of MI. Instead of merely reading and studying to put information in our short-term memories only to regurgitate that information on a test, you allowed us to actually use our brains, to get creative, and to do something unusual. Words are difficult to store in my mind, but a picture, no matter how good or bad, or whatever reason it was drawn, lasts a lifetime. Drawing this picture not only presented me with a challenge, but it was something unique, and I had fun doing it!

(Jewel, 18)

I really enjoyed using my imagination in school in this way instead of using it as an escape as I have in the past.

(Chuck, 22)

"All the arts we practice are apprenticeship. The big art is your life."

—M. C. Richards

Using art to learn terms in textbooks is not something I do often, but it really helps. You can do whatever you want with art, be it abstract or just sketching. Another plus about this learning option is that you don't have a sense of doing "homework," but in fact what you're doing and learning the whole time *is* learning, and it is *fun!*

(Monica, 18)

By making my own artwork creative and colorful, yet still very informative, it was easier for me to grasp the concepts of the emotions

portrayed in the book. I think this learning option has been beneficial to me because I learned new techniques about painting that I never would have known, had I not done such a project. I had fun experimenting with the different colors and drawing the cute little cartoon characters. Life is all about having fun and being creative, along with learning while you're doing it!

(Fernando, 27)

This learning option has assisted me in learning the material presented in the textbook by allowing me to visually represent how I see the concepts in my mind and try and have them make sense to others at the same time which ensures that I have to know how to explain what I am trying to convey in the painting. The gradation of the colors is very important, at least to me, and is one of the hardest concepts for me to verbally explain and by actually creating it made it easier and clarified in my own mind what I was attempting to convey.

(Amy, 38)

This painting is a great way for me to see how I work in telling information to myself and others. I always explain things to people by telling a story. Painting a picture provides me a chance to do that. Was this beneficial? I would like to give a great big YES! Thanks to the learning options, I actually enjoyed college! I love being able to say,

"You know what, I think I'll do a spatial learning option to help me understand things I can't quite grasp."

(Jack, 19)

"Painting is just another way of keeping a diary."

—Pablo Picasso

I enjoy being able to create something visual for myself and others to see and understand. Although it is abstract in a way, it can be easily applied after explanation. I was glad to be able to successfully display a concept with my own interpretation, making the concept more clear to myself and others studying psychology.

(Debora, 24)

My understanding was reinforced by continually referencing the textbook during the creative process. It was also reinforced while I developed the analysis of the painting.

(Arthur, 18)

I studied REM and NONREM, insomnia, and hypnosis, because I realized again how all relate in some way . . . everything came to me and my mind went hog wild on how everything relates. I suddenly began to get these neat ideas on what I wanted to draw.

(Colleen, 22)

Drawing a picture to represent ideas and terms is quite fun. I am not much of an artist, but I enjoy daydreaming (term) ideas that could be used to explain something. From the original idea I always find a way of relating it to others. Drawing this picture did a lot for me. It also made me think about the chapter on memory.

(Rudy, 22)

"Each painting has its own way of evolving. . .. When the painting is finished, the subject reveals itself."

—William Baziotes

Applied Term Paper Learning Option

The applied term paper provided Erin (age 18) the opportunity to utilize linguistic/interpersonal intelligences as she carefully analyzed, examined, and provided examples on how she incorporated the study of psychology and what she has learned into her life. The term paper must incorporate 12 to 15 terms, themes, concepts, topics, or ideas taken from at least *five* chapters in the textbook. The paper must include a cover page and at least eight typed, double-spaced pages of text. This assignment is challenging and enjoyable for someone who likes to write! This is what Erin had to say about writing the term paper:

Throughout this semester I was able to relate a lot of psychology to my life. I thought that to be able to associate anything dealing with psychology to your life, you had to be crazy, or at least be abnormal, but as I look back on the items we covered, I realize that everyone shows some of the items in psychology at least some time in their life . . . I learned in many new and exciting ways that I never thought would be taught in college. Thus, as I end the tale of how this psychology class has affected my life and how I can relate psychology to my life, I just want to say that I do not think I would have taken away as much knowledge as I did from this class if I was in a regular class that just made you study and read and not make learning enjoyable.

"What lies behind us and what lies before us are tiny matters, compared to what lies within us."

—Ralph Waldo Emerson

The following are further examples of how students used the applied term paper as a means of reflecting upon how they learned academic material throughout the course:

> Psychology 101 is a class that I have avoided in the past, because of all the negative comments I had heard from other students. I had visions of absolute boredom, for I expected to be listening to lectures, reading chapters, answering questions at the end of the chapters, and then taking a written test with terminology I couldn't even pronounce! I couldn't have been more misled. In the following pages, I hope to present the enlightening positive experiences.
>
> (Grace, 19)

> Well, that is the "Study of Psychology As It Applies to My Life." I never thought that I would have the opportunity to review and analyze my own life . . . my accomplishments and my mistakes . . . I guess I could sum up this learning option as an eye opening experience, as I've never received anything personal from a term paper before.
>
> (Louie, 25)

> My journey through this course has been an extremely captivating one. I explored various parts of the field and expect that I will be doing a lot more studying in certain areas. I believe that I have the basic knowledge to tackle a few more psychology classes throughout my education, and I have the inspiration and techniques to do it. And that's something I have never had before.
>
> (Maury, 48)

> Certain chapters of my textbook were especially significant to me because they helped me identify myself and how I have developed. Specifically, Chapter 6 on Learning has influenced me substantially. The concept of classical conditioning has enabled me to understand and explain an aversion I have to a certain food. There are many other chapters that have helped me apply psychology in my life, as well as several other class discussions which have bolstered my respect for and understanding of psychology in my life. By seeing how I was able to use the concepts (not just read about them in the textbook) in reality (through group discussions, role-playing, etc.), my ability to use psychology to any degree when I eventually leave the class has been strengthened.
>
> (Evelyn, 22)

> In conclusion, psychology has been and will continually be a tool of reference for me. When I first entered psychology and listened to a man in jeans and a collared t-shirt tell me that I did not have to take a

test, I not only thought he was insane, but I also thought that I would learn nothing. However, much to my surprise, I honestly believe that I will walk away from Psychology 101 with more useful knowledge than I will with any other class from this year or future years.

(Florence, 29)

Applying psychology is something I do all the time when I deal with problems or when I try to figure out why I'm in a bad mood. I just didn't know it was psychology. I also thought psychology was for crazy people or people in therapy. Now I have a much better understanding of what psychology is and how it is applied.

(Adalberto, 19)

"Learning is movement from moment to moment."

—J. Krishnamurti

The Study of . . . As It Applies to My Life

I would like to add one final note regarding the application of the term paper learning option to other disciplines. Providing students an opportunity to reflect upon and write about the study and application of *any* discipline challenges them to review and think about what they have learned throughout the semester. More importantly, it gives them the opportunity to comment on the *connections* between the discipline and real-life application.

Musical-Rhythmic Learning Option

"I merely took the energy it takes to pout and wrote some blues."

—Duke Ellington

The musical-rhythmic learning option provided Tony (age 20) the opportunity to compose and perform a violin concerto utilizing concepts, themes, topics, or ideas from the chapter on developmental psychology (Lifespan Psychology). Before his performance he asked us to listen carefully; he promised to take us musically through the different stages of the lifespan. After his performance, he explained the concerto in detail and

answered questions from classmates. Application of the option may include: composing a rap song, or another piece of music, playing a musical instrument, singing a song, or selecting specific music that pertains to what is being studied in the course. (*Application: Violin Concerto "Dance of Life"*)

1. Identify and explain 4 to 5 concepts, terms, themes, sounds, rhythms, melodies, included in your application. Be aware of and comment on rhythm, timbre, and the emotional power of music incorporated into your work. Be specific; show examples, and be prepared to explain in class.

 By combining two drastically different songs, I will attempt to musically show the life span of an average human being. The songs are Courante and Prelude, composed by Henri Eccles. Developmental psychology studies the physical and psychological functions that occur throughout the entire life span of a person. The slowness and softness of the first quarter of the song represents a baby's infancy followed by childhood. This is a time when things are slow and the rate of learning is also slow. The baby crawls, then pretty soon starts to walk and starts childhood with his first words.

 As the song changes from Prelude to Courante, the song speeds up in intervals to simulate that the child is growing up and learning faster. Everything gets a little more complicated. The song reaches a climax of speed and loudness, then begins to slow down again, and gets softer, simulating how that child went through adulthood, attained his maximum potential, and realized he couldn't go any higher. The end of the song is very slow, representing old age and retirement. One gets to reflect one's past before dying; and then, like life, the song fades away.

"What we play is life."

—Louis Armstrong

2. How has this musical/bodily/intrapersonal experience assisted or reinforced your understanding of concepts, terms, topics, discussed in class or mentioned in the textbook? Be specific and give examples with your explanation.

This musical experience, with the help of choosing the right song, helped me retain the information learned in Chapter 4. Every time I played the selected song, Prelude and Courante, it reminded me of life, how it starts slow, then speeds up, and then slows down again. I know that whenever I decide to practice the song again, I'm sure it will remind me of this experience. This musical application to psychology also made me think of where I am in terms of this song. Am I just gaining speed, preparing to reach that climax in life?

3. Provide a paragraph (or longer!) of reflection and evaluation of this musical-rhythmic experience. This learning option provided an opportunity of learning academic material in a different way. By completing the assignment in this way, was it beneficial in helping you LEARN and UNDERSTAND the material better? How and why? Be concise and specific.

I really enjoyed touching up on my skills and receiving a grade for it. It's been a long time since I performed on my violin, and I especially enjoyed relating it to something I never thought I would. It did take a lot of practice, so I wouldn't sound terrible. Overall, I would say it was very beneficial in helping me understand the chapter, because I know I can't forget this stuff as long as I have my violin and that song.

Tony has demonstrated in depth and detail his understanding of academic material by applying a domain (music) that feels comfortable and makes sense to him. Further examples of learners applying what they learned by using music follow:

The song I selected to sing, "I Dreamed a Dream" from the musical Les Miserables is a very touching song. The emotions of this song are extremely strong. I have associated the song with a woman who has multiple personality disorder, explaining her terror and her messed up life. Her words cut like a knife when she says, "I dreamed a dream my life would be so different from this hell I'm living." As an audience, we witness her raw feelings. The rhythm is slow and somewhat chaotic . . . The sound of the entire piece is mezzo piano . . . every part of the song shows a different part of her turmoil.

(Marian, 19)

For my musical application I decided to use many different songs that have affected my life in one way or another to explain the chapter on memory (Chapter 7). My choice from the memory chapter was long-term memory. Long-term memory consists of different memory parts. There is procedural and declarative, and under declarative

exists both semantic and episodic. As you probably know, I played a few songs on my piano and recorded them.

(Daniel, 22)

I feel very fortunate that I was able to apply my favorite activity to this class. I enjoy singing and creating ideas. This learning option has been so helpful in allowing me to apply concrete terms to a hobby of my own. I know I will never forget how to explain schizophrenia.

(Josie, 26)

"Music is your own experience, your thoughts, your wisdom. If you don't live it, it won't come out on your horn."

—Charlie Parker

"BUT HOW DO YOU GRADE THIS STUFF?"

The purpose of the MI learning option is to provide students with the guidance and opportunity for learning academic material in a *different* way. The instructor or trainer is the content "expert" and makes the decision on what terms, concepts, and topics students need to know. The teacher provides the guid-

ance by giving students key terms, concepts, topics, from the chapter or text so the student has *choices* and *options* to select from.

It is the choice and responsibility of teachers to determine how many terms, concepts, or topics they want students to cover. Results from the pilot study have indicated students **want, need,** and **appreciate** knowing exactly what is expected of them and where they can find the resources (e.g., textbook, other resources they are exposed to).

By providing choices and creative options that accentuate the different intelligences, learners are given the chance to use their creativity and imagination and "shine" in areas in which they are strong. By sharing what they have learned in front of their classmates, they become "mini-experts" and/or "co-facilitators" in the learning process. The written and reflective component is an integral part of the learning experience. The learning option also provides the opportunity to **reinforce** material covered in class. For example, the same terms, concepts, or topics, used in the learning options can be used in "tests." The more ways learners are exposed to information, the more likely reinforcement and retention will take place.

"They won't care how much you know until they know how much you care."

—Anonymous

Creative Grading for Understanding

As the content expert, teachers or trainers decide what they want their students to learn, know, and understand. Upon completion of the learning option students are expected to satisfy the following criteria to successfully complete the assignment and earn the maximum number of points or earn the highest grade. The following is a list of points to consider as you utilize the MI/LfU grading rubric:

1. Evaluating and assessing **creativity**:

 Creating poems, collages, drawings or songs. How much time did the student spend on the learning option? Ask them! They will tell you. Did they follow the guidelines set forth in the learning options (e.g., color, form, tex-

ture)? How creative were they? Did they use their imagination?

2. Evaluating and assessing the **demonstration/performance** of understanding:

 How well did the student explain, recite, or perform the learning option (e.g., collage, poem, song, dance)? How well did they respond to your questions or their classmates questions regarding their work? In their explanation of what they have created, it's OK if they use the written component of the learning option to help in the explanation.

3. Evaluating and assessing the **written** quality of understanding:

 How well did the student complete the written component of the learning option? How well did the student address, cover, and complete the three questions asked in the learning option? Are the responses long enough? Has the student linguistically proven he or she knows and understands the material?

Creative Grading Rubric

Most teachers view the assignment of grades as burdensome and unpleasant yet something we have been doing and will continue to do for a long time. I am not going to spend time arguing pro and con on the effectiveness of grades. In my opinion, grades are detrimental to real learning and understanding. I don't know how many times I have heard college students ask, "What do I need to do to get an A in this course?" It amazes me how deeply ingrained is the idea that a letter grade equates with what a person knows and understands. The long history of assigning grades doesn't promise an end to this important component of evaluation soon. I suggest no blame; I can, however, propose a different evaluation and assessment format that effectively works for me. The following grading rubric provides the teacher or trainer a tangible way of grading for understanding. The learner is assessed utilizing five criteria: creativity/imagination, demonstration/performance, organization/format, reflection/meta-cognition, and evidence of understanding. Indicators within the criteria provide specific areas of competence. The point total or grading scale can be adjusted to reflect the scale already used by individual instructors or trainers.

"The creation of something new is not accomplished by the intellect but by the play instinct acting from inner necessity. The creative mind plays with the objects it loves."

—C. G. Jung

Learners are given the grading rubric at the beginning of the course. They need to know right at the start of the course what they need to do to get an "A!" The rubric provides an opportunity for the teacher to individually point out to students areas of strength and areas that need improvement.

MI/LfU Creative Grading Rubric and Assessment

What is a rubric?

A rubric is a set of guidelines for comparing students' work. Rubrics provide **descriptors** for varying levels of performance, and rubrics answer these questions: By what criteria is **performance** judged? What does the **range** in the quality of the performance look like? How are the different levels of quality **described** and **distinguished** from one another?

Assessment helps teachers AND students:

- set standards
- create instructional pathways
- motivate performance
- provide diagnostic feedback
- evaluate progress
- communicate progress to others

The MI/LfU Creative Grading Rubric used for the pilot program follows:

MI/LfU Creative Grading Rubric

Learner: _____ Course: _____ Date: _____

Goal/Standard: To learn, understand, and apply academic information in a variety of ways.

CRITERIA	INDICATORS	1 not yet!	2 some	3 all	4 WOW!	SCORE x5 (20)
1. Creativity/Imagination	* generated new/ relatively novel ideas * imaginative verbal/ spatial connection * visual appeal * high quality	not yet!	some	all	WOW!	x5 (20)
2. Demonstration/ Performance	* explanation/ recitation (poem) * accuracy * eye contact * performance (music, dance) * communication skills	not yet!	some	all	WOW!	x5 (20)

CRITERIA	INDICATORS	1	2	3	4	SCORE
3. Organization/Format	* completeness * spelling * grammar usage * neatness	not yet!	some	all	WOW!	___x5 (20)
4. Reflection/ Meta-Cognition	* ability to self assess * depth of reflection * insight into own learning/feelings * learning in a new/different way	not yet!	some	all	WOW!	___x5 (20)
5. Evidence of Understanding (concepts, terms, themes, topics)	*represents knowledge in many ways * uses knowledge in new situations * real-world application and understanding	not yet!	some	all	WOW!	___x5 (20)

(continued)

MI/LfU Creative Grading Rubric (Continued)

LEARNING OPTION: _____

COMMENTS: _____

SCALE Final Score:_____
A = 93-100 (100)
B = 85-92 Final Grade: _____
C = 77-84
D = 69-76
F = Below 68

Note: To change a rubric to a traditional grade that students can understand, use a scale to convert points to a percentage, or as in this example, multiply each score to arrive at a percentage that can be converted to a letter or number grade.

It has been both challenging and rewarding selecting comments from students. It was fun rereading the many comments expressed by students who have taken classes utilizing a different approach to learning. MI/LfU is not THE way; it's A way!

Included at the end of this chapter are 10 MI/LfU learning options. They are generic and can be applied to any college-level class, business training class, high school or adult learning environment. All it takes to apply the learning options is a willingness by teacher and learner to be creative; be willing to get out of *"comfort zones,"* have *fun,* and go for it!

"Successful teachers are vital and full of passion. They love to teach, as a painter loves to paint, as a writer loves to write, as a singer loves to sing. They are people who have a motive, a passion for their subject, a spontaneity of character, and enormous fun doing what they do."

—Thomas Cronin in Celebrating College Teaching, Political Science & Politics, *September 1991*

SCULPTURE LEARNING OPTION

NAME: _____ COURSE: _____

TITLE: _____

DATE: _____ CHAPTER(S): _____

You will be given a number of key terms, concepts, or topics per chapter to select from in designing your sculpture. Using the basic guidelines provided by the art department, you want to include the following basic components of art into this learning option: texture, images, colors, shapes, and form. You are encouraged to be CREATIVE, use your IMAGINATION, and have FUN in completing this assignment. Spend some reflective time thinking about and answering the following questions. Type your responses on separate sheets of paper. The paper should be a minimum of 1-1/2 to 2 pages in length.

1. Identify and explain _____ to _____ concepts, terms, themes, topics, or visual themes you have included from the chapter in your artwork. Be aware of and comment on texture, color, shape, form, and design incorporated into your work. Be specific, show examples, and be prepared to explain in class.

2. How has this *bodily/spatial/intrapersonal* experience assisted or reinforced your *understanding* of concepts, terms, topics discussed in class or mentioned in the textbook? Be specific and give examples with your explanation.

3. Provide a paragraph (or longer!) of reflection and evaluation on this sculpture experience. This learning option provided an opportunity to learn academic material in a *different* way. By completing the assignment in this way, was it beneficial in helping you LEARN and UNDERSTAND the material better? How and why? Be concise and specific.

"He who cherishes a beautiful vision, a lofty ideal in his heart, will one day realize it."

—James Allen

POETRY LEARNING OPTION

NAME: _____ COURSE: _____

TITLE: _____

DATE: _____ CHAPTER(S): _____

You will be given a number of key terms, concepts, or topics per chapter to select from in creating your poem. The poem is to be 12-15 stanzas long, and you will be reciting the poem in class. You are encouraged to be CREATIVE, use your IMAGINATION, and have FUN in completing this assignment. Spend some reflective time thinking about and answering the following questions. Type your responses on separate sheets of paper. The paper should be a minimum of 1-1/2 to 2 pages in length.

1. Identify and explain _____ to _____ concepts, terms, themes, topics, or ideas you created and wrote about in your poem. Be aware of and comment on mood, rhythm, and emotion incorporated into your work. Be specific, show examples, and be prepared to explain in class.

2. How has this *linguistic/imaginative/intrapersonal* experience assisted or reinforced your *understanding* of concepts, terms, topics discussed in class or mentioned in the text-book? Be specific and give examples with your explanation.

3. Provide a paragraph (or longer!) of reflection and evalua-tion on this poetry writing experience. This learning option provided an opportunity to learn academic materi-al in a *different* way. By completing the assignment in this way, was it beneficial in helping you LEARN and UNDER-STAND the material better? How and why? Be concise and specific.

"Life shrinks or expands in proportion to one's courage."

—Anaïs Nin

JOURNAL WRITING LEARNING OPTION

The Psychological Journal is designed for the student who really enjoys **Writing!**

1. The journal is to be an intellectual exercise in explaining one's own **thoughts, feelings,** and **ideas** about what is read in the textbook, discussed in class, or learned outside of class.
2. The journal provides students a **less formal** and **less threatening** way to write and express themselves.
3. Journal entries are to be made **frequently,** avoiding long periods of delay.
4. An **ongoing** effort is a condition for earning the maximum number of points.
5. The **quality** of your entries is essential in earning a good grade.
6. A journal with a few entries of high quality will earn **more** points than a journal with more entries of superficial one-liners.
7. All journal entries must include the **date** of entry.
8. The idea is to continually monitor what you're learning about the material at hand and **write** on it!!
9. The journal is to be started **immediately**!!
10. Use the last 2 pages of your journal entry to comment and reflect upon how this writing option (verbal/linguistic) has helped you better **understand** the material covered in your textbook or discussed in class. Be specific with examples.

WRITE,

WRITE,

WRITE!!!

"The life which is not examined is not worth living."

—*Plato*

CHAPTER COLLAGE LEARNING OPTION

NAME: _____ COURSE: _____

DATE: _____ CHAPTER(S): _____

You will be given a number of key terms, concepts, or topics per chapter to select from in designing your collage. You are encouraged to be CREATIVE, use your IMAGINATION, and have FUN! Upon completion of your collage, spend some reflective time thinking about and answering the following questions. Type your responses on separate sheets of paper. The paper should be a minimum of 1-1/2 to 2 pages in length.

1. Identify and explain _____ to _____ concepts, terms, themes, topics, or ideas that are *visually* represented in your collage. Be specific, show examples, and be prepared to explain in class.

2. How has this *spatial/logical/bodily/intrapersonal* experience assisted or reinforced your *understanding* of concepts, terms, topics discussed in class or mentioned in the textbook? Be specific and give examples with your explanation.

3. Provide a paragraph (or longer!) of reflection and evaluation on this collage experience. This learning option provided an opportunity to learn academic material in a *different* way. By completing the assignment in this way, was it beneficial in helping you LEARN and UNDERSTAND the material better? How and why? Be concise and specific.

"Shoot for the moon. Even if you miss it you will land among the stars."

—Les Brown

CREATIVE DANCE LEARNING OPTION

NAME: _____. COURSE: _____

TITLE OF DANCE: _____

DATE: _____ CHAPTER(S): _____

You will be given a number of key terms, concepts, or topics per chapter to select from in creating your dance. Using the basic guidelines provided by the dance department, you want to include the following basic components of dance movement into this learning option: space, energy, time, form, intent/content. You are encouraged to be CREATIVE, use your IMAGINATION, and have FUN as you design, choreograph, and perform your dance. Spend some reflective time thinking about and answering the following questions. Type your responses on separate sheets of paper. The paper should be a minimum of 1-1/2 to 2 pages in length.

1. Identify and explain _____ to _____ concepts, terms, visual themes, and physical movements included in your dance. Be aware of and comment on space, energy, and time. Be specific, show examples, and be prepared to explain in class.

2. How has this *bodily-kinesthetic/logical/imaginative* experience assisted or reinforced your *understanding* of concepts, terms, topics discussed in class or mentioned in the textbook? Be specific and give examples with your explanation.

3. Provide a paragraph (or longer!) of reflection and evaluation on this dance experience. This learning option provided an opportunity to learn academic material in a *different* way. By completing the assignment in this way, was it beneficial in helping you LEARN and UNDERSTAND the material better? How and why? Be concise and specific.

"Nature has been for me, as long as I can remember, a source of solace, inspiration, adventure, and delight;
a home, a teacher, a companion"

—Lorraine Anderson

DRAWING/SKETCHING/PAINTING LEARNING OPTION

NAME: _____ COURSE: _____

TITLE: _____

DATE: _____ CHAPTER(S): _____

You will be given a number of key terms, concepts, or topics per chapter to select from in drawing your picture. Using the basic guidelines provided by the art department, you want to include the following basic components of art into this learning option: color, texture, design, balance, and form. You are encouraged to be CREATIVE, use your IMAGINATION, and have FUN in completing this assignment. Spend some reflective time thinking about and answering the following questions. Type your responses on separate sheets of paper. The paper should be a minimum of 1-1/2 to 2 pages in length.

1. Identify and explain _____ to _____ concepts, terms, themes, topics, or images you have included from the chapter in your artwork. Be aware of and comment on color, texture, design, balance, and form incorporated into your work. Be specific, show examples, and be prepared to explain in class.

2. How has this *spatial/bodily/intrapersonal* experience assisted or reinforced your *understanding* of concepts, terms, topics discussed in class or mentioned in the textbook? Be specific and give examples with your explanation.

3. Provide a paragraph (or longer!) of reflection and evaluation on this spatial experience. This learning option provided an opportunity to learn academic material in a *different* way. By completing the assignment in this way, was it beneficial in helping you LEARN and UNDERSTAND the material better? How and why? Be concise and specific.

"True life is lived when tiny changes occur."

—Leo Tolstoy

MUSICAL-RHYTHMIC APPLICATION LEARNING OPTION

NAME: _____ COURSE: _____

 APPLICATION: _____

DATE: _____ CHAPTER(S): _____

You will be given a number of key terms, concepts, or topics per chapter to select from in completing your musical-rhythmic application. You have the opportunity to create, compose, and/or develop a musical application as it pertains to concepts, themes, or ideas within this discipline. Application may include: composing a rap song, or another piece of music, playing a musical instrument, singing a song, or selecting specific music you feel pertains to what is being studied in the course. You are encouraged to be *CREATIVE*, use your *IMAGINATION*, have *FUN* in completing this assignment. Send some reflective time thinking about and answering the following questions. Type your responses on separate sheets of paper. The paper should be a minimum of 1-1/2 to 2 pages in length.

1. Identify and explain _____ to _____ concepts, terms, themes, sounds, rhythms, melodies, included in your application. Be aware of and comment on rhythm, timbre, and the emotional power of music incorporated into your work. Be specific; show examples, and be prepared to explain in class.

2. How has the *musical/bodily/intrapersonal* experience assisted or reinforced your *understanding* of concepts, terms, topics, discussed in class or mentioned in the textbook? Be specific and give examples with your explanation.

3. Provide a paragraph (or longer!) of reflection and evaluation of this musical-rhythmic experience. This learning option provided an opportunity of learning academic material in a *different* way. By completing the assignment in this way, was it beneficial in helping you LEARN and UNDERSTAND the material better? How and why? Be concise and specific.

"Music is born with each child and accompanies him throughout life."

—Frances Bebey

"The Study of Psychology As It Applies To My Life"
Applied Psychology Paper Learning Option

This learning option provides an opportunity to utilize linguistic and intrapersonal intelligences as you carefully *analyze, examine,* and provide *examples* of how you've incorporated the study of psychology and what you have learned this semester into your life.

The paper will consist of a cover page, eight (8) full pages, double-spaced, typed or word processed. This assignment is challenging and a lot of fun! Late papers will not be accepted! The paper is to incorporate **12-15** terms, concepts, themes, or ideas taken from at least **FIVE (5) CHAPTERS.**

As you read and study a chapter, it may be a good idea to write down ideas and areas of interest that may be included in your paper.

SAMPLE PAPERS ARE AVAILABLE FOR YOU TO LOOK AT. JUST ASK ME!

WRITE,

WRITE,

WRITE!

"I touch the future. I teach."

—Christa McAuliffe

BOOK REPORT LEARNING OPTION

NAME: _____ DATE: _____

TITLE: _____ AUTHOR: _____

COURSE: _____ PUBLISHER & DATE: _____

NUMBER OF PAGES: _____

FORMAT This *linguistic/intrapersonal* learning option provides the opportunity to read and report on a book that pertains to this course. You are encouraged to select a book that expands on a theme, concept, topic, idea, or area of study covered in your textbook or discussed in class. Follow the format carefully. A minimum of 4-5 typewritten pages are required. Let me know if you need some assistance identifying potential topics to read.

To *understand* any book more thoroughly, analyze it by answering these questions on each level of comprehension.

A. Literal Comprehension
1. What is/are the main ideas/major concepts expressed in the book?
2. What specific examples/details does the author use to support the major concepts?

B. Critical Comprehension
1. What is the theme/purpose of the book?
2. How is the title related to the theme/purpose of the book?
3. How effective is the conclusion of the book?

C. Affective Comprehension
1. Explain what feeling you have for the major concepts in the book.
2. Find some passages/chapters that you feel are well written.
3. Explain why you do (or do not!) like the book. Give specific details to support your feelings.

D. Upon completion of this learning option, spend some reflective time thinking about and answering the following question:

Provide a paragraph (or longer!) of reflection and evaluation on this reading experience. This learning option provided an opportunity to learn academic material in a *different* way. By completing the assignment in this way, was it beneficial in helping you LEARN and UNDERSTAND the material better? How and why? Be concise and specific.

ACTING/ROLE-PLAYING LEARNING OPTION

NAME: _____ COURSE: _____

DATE: _____ CHAPTER(S): _____

PRESENTATION: _____

This *linguistic/bodily-kinesthetic/imaginative* learning option provides the opportunity to learn about an individual who has made a significant contribution to this discipline. By researching the background of the individual, you have the option of either **becoming (acting)** the person or **role-playing** the part of an associate of the person you select. You are encouraged to be CREATIVE, use your IMAGINATION, and have FUN in completing this assignment. Spend some reflective time thinking about and answering the following questions. Type your responses on separate sheets of paper. The paper should be a minimum of 1-1/2 to 2 pages in length. Come by my office and I can provide examples of notable individuals from the discipline.

1. Identify and explain _____ to _____ concepts, themes, ideas, topics incorporated into your presentation/performance. Include anything that might present the person in a professional *and* personal way.

2. How has this experience assisted or reinforced your *understanding* of concepts, themes, ideas, topics discussed in class, covered in the textbook, or relative to this discipline? Be specific and give examples with your explanation.

3. Provide a paragraph (or longer!) of reflection and evaluation on this acting/role-playing experience. This learning option provided an opportunity to learn academic material in a *different* way. By completing the assignment in this way, was it beneficial in helping you LEARN and UNDERSTAND the material better? How and why? Be concise and specific.

"To accomplish great things, we must not only act but also dream, not only plan, but also believe."

—Anatole France

The next chapter will provide an overview of the evaluation process used during the MI/LfU Pilot Study. Learners, in their own voices, will provide thoughts, feelings, and commentary on the effectiveness of applying multiple intelligences and creativity in learning.

CHAPTER SIX

In Their Own Voices: Students' Reflections on Learning

Learning theorists advocate the value of having students think more consciously (or "metacognitively") about their own learning and thinking. The pilot study curriculum included a written component of self-reflection and evaluation. Inviting learners to comment on their own learning challenges them to look deeper into the learning process by reflecting, composing, and describing in their own words the learning and its value to them. Giving the evaluation at the end of the course serves primarily as a learning strategy, providing understanding for the learner, teacher, and institution as to *how* people learn.

> *"Typical academic activities in college are notoriously arid when it comes to experience, and students are quick to notice it."*
>
> **—Peter Ewell, "Organizing for Learning: A Point of Entry," 1997**

Self-evaluation assists students in reflecting upon the quality and substance of their work. It is a mechanism for students to construct meaning into what they have learned and describe new insights in that process. It also strengthens their analyzing and synthesizing skills. Self-evaluation provides an effective form of feedback for the teacher or trainer as well. Through learner evaluations I have learned what keeps students *motivated* to learn. Student self-evaluation offers learners an opportunity to put themselves where they truly belong—at the center of learning! The potential of learner self-evaluation as an educational tool is tremendous. Why? Because everybody wins!

MOTIVATION: WHAT "MOVES" US TO DO THINGS?

Motivation, like emotion, comes from the Latin root *movere*, meaning "to move." Both motivation and emotions are feelings that cause us to move or be moved. I have always been fascinated with what "moves" people to do what they do. As a psychological educator I am especially interested in the *what* and *why* of optimal student learning. Motivation is the driving force that leads someone to action.

There are basically two kinds of motivation: extrinsic and intrinsic. Extrinsic motivation comes from outside a person. For example, many people are employed in jobs they have little personal interest in; however, because the employment earns them income, they satisfy an outside incentive: making money.

Conversely, intrinsic motivation comes from inside a person. For example, a person who engages in an activity or remains in a job because it provides personal satisfaction and is meaningful in its own right without regard to outside rewards is intrinsically satisfied. There is a tendency for extrinsically motivated learners to take the quickest, easiest method to get the grade. Creative learners consciously decide to follow their own path. They do so because they want to, not because they feel they have to.

"All human beings, by nature, desire to know."

—Aristotle, Philosopher

INTRAPERSONAL INTELLIGENCE:
THE ABILITY TO SELF-ASSESS

The ability to self-assess is an integral component of learning for understanding. This ability is often important for achievement and success in any field or endeavor. This ability to think about thinking encourages us to step back from our work, where all kinds of thoughts, feelings, appraisals, and decisions may occur. In self-assessment we ask ourselves questions like: "Is this what I really wanted to do? Am I satisfied with my work? Is there any unfinished business I need to attend to?" These types of reflective questions provide instructors and learners themselves with valuable information about learning. This stepping-back process allows learners to slow down and contemplate what they are

doing and why. Reflective activity reveals to the instructor each learner's application and understanding, making it easier to respond to individual learning circumstances.

Becoming a Lifelong Learner

In my way of thinking, one of the advantages of providing a multiple intelligences/learning for understanding curriculum is that it encourages students to begin thinking about becoming lifelong learners. Information today is more plentiful, global, and available. Choices and options are part of living life right *now* for students; not after they graduate. The more information an individual has in knowing *where* to find resources the less stressful and frustrating learning becomes.

"Anyone who stops learning is old, whether at twenty or eighty. Anyone who keeps learning stays young. The greatest thing in life is to keep your mind young."

—Henry Ford

Ask Them and They Will Tell You!

The following is a sample of the evaluation/assessment format used in the MI/LfU classes followed by real students' responses. I hope you enjoy all the interesting, insightful, and revealing comments on how people perceive learning. It has been rewarding to go back and read what learners have to say about *their* learning.

MI / LfU Pilot Study (1994-96)

Psychology 101

3	Honors Classes	44	Students
2	Afternoon Classes	27	Students
5	Evening Classes	60	Students
10	Classes (Total)	131	Students

REFLECTIONS IN LEARNING

Name: _____

Course: _____

"The mind is a fire to be kindled, not a vessel to be filled"

Plutarch

This past semester you have been involved in a different approach to learning a college-level course. The teaching/learning format has incorporated Howard Gardner's *multiple intelligences* (linguistic, logical-mathematical, intrapersonal, musical, bodily-kinesthetic, spatial, and interpersonal) and *learning for understanding* (the ability to apply knowledge, concepts, or skills acquired in a school setting to a *new* situation, where the knowledge is relevant).

1. In reviewing and reflecting upon the information learned from taking the MI inventory (TIMI) at the beginning of the course, what do you now believe to be your *dominant* or *preferred* intelligences? Be specific and comprehensive in your response.

2. You were provided a variety of learning options for each chapter studied in the course. What *specific* learning options did you select and complete? Why did you select these? How did these options help you *better* understand the chapter(s)? Be specific and give examples.

3. Do you feel reading/learning/doing and thinking about the course in this manner has provided an *adequate* foundation for taking other courses in this discipline? Why? Why not? Elaborate, be specific and give examples.

4a. How has your motivation to *learn* the material from the course been affected by having options to select from? Be specific and give examples.

4b. How much time did you spend studying/doing/or thinking about the course *outside* of class? (Circle one).

 1. 03-06 hours weekly

 2. 06-10 hours weekly

 3. 10-15 hours weekly

 4. 15-20 hours weekly

 5. 20+ hours weekly

4c. What was your *motivation* for spending this amount of time learning and applying the material covered in your textbook or in class? Be specific and give examples.

5a. In what *other* college classes could an MI/LfU approach be effectively used?

5b. How might this *approach* be utilized in other courses? Give examples.

Thank you for taking some *risks,* being *creative,* and trying something *different!*

"It always comes back to the same necessity: go deep enough and there is a bedrock of truth, however hard."

—May Sarton

1. In reviewing and reflecting upon the information learned from taking the MI inventory (TIMI) at the beginning of the course, what do you now believe to be your dominant or preferred intelligences? Be specific and comprehensive in your response. (100% of the students identified their preferred intelligences.)

My preferred intelligences are visual/spatial and interpersonal. I learn a lot more if I am able to connect pictures or other visual aides with the information I am supposed to be learning. If I can see something and have a mental picture of it in my head, then I can remember it. I also love to work with people. By working together with other minds, I am able to get a more rounded perspective on learning than I would be able to get on my own.

(Dena, 18)

I prefer bodily-kinesthetic, interpersonal, and logical-mathematical. I enjoy working with my hands or mechanical things. The most enjoyable job I ever had was (working as) a motorcycle mechanic I worked with my hands. The job involved a lot of problem solving; diagnosing the problem was not always easy . . . We would ask each other for help. A fresh mind with a new approach usually seemed to work wonders.

(Jim, 33)

The multiple intelligences (identified by the TIMI) I felt were accurate—bodily-kinesthetic, visual/spatial and intrapersonal, in that order. My favorite things are racquetball and martial arts, closely followed by building model rockets and photography.

(David, 29)

"The learners and the learning facilitators must be aware of the awesome power that can be released when learning works well."

—Terry O'Banion, League for Innovation in the Community College

My preferred intelligences were logical-mathematical, bodily-kinesthetic, visual/spatial, and interpersonal. Through these new learning choices I've utilized my full potential to truly understand psychology, and feel I have succeeded. Now, I understand myself better than ever before.

(Emma, 38)

Definitely visual/spatial and linguistic are my two strongest points of intelligence. Although I am not an 'artsy' person and don't have an expertise in sculpture, or drawing, or anything like that, I do love to work with paints ... and I just love to have a pen in my hand, whether I'm doodling or writing.

(Brandi, 20)

... I use my preferred visual/spatial intelligence to not only reinforce my learning of the facts related to the concept, but also to develop and illustrate my personal viewpoint ...

(Celeste, 29)

I find stretching the mind grabs my attention. If you give my consciousness something to chew on, it suddenly becomes very alive. The more abstract the idea, the more exotic the flavor, the more I am enticed. I am bored with meat and potatoes. The bodily-kinesthetic intelligence is my preference. If I am not active, either mentally or bodily, I have a tendency to fall asleep ...

(Anna, 40)

I prefer learning musically and intrapersonally ... I have an ear for music ... I love to write or listen to music by myself.

(Paul, 19)

One of my preferred intelligences is visual/spatial. I always feel comfortable and inspired when I express my thoughts through drawings.

(Rebecca, 18)

After looking back over the semester in this psychology class and having choices on what I could do, I realized that I am a very visual/spatial learner. I really enjoyed doing the chapter collages, and they helped me to learn the material that was covered in the textbook and in class.

(Brian, 18)

My preferred intelligences are bodily-kinesthetic and visual/spatial. This was also reinforced throughout the semester as I found enjoyment in creating my collages and sculpture. I have always liked doing things with my hands, but I was never really given the chance to learn by using them.

(Michele, 20)

I know that I am a very spatial learner because I like being able to see the meanings of things rather than just hearing a lecture or reading

about them. Doing artwork, such as drawing or painting, helps me to see the meaning of things.

(Michelle, 19)

"Nothing is more dangerous than an idea when it is the only one you have."

—Emile Chartier

I was surprised to find out how strong my spatial intelligence was. Now I know why when I see something, it tends to stick better. I really enjoyed doing the collages and that information will definitely stay with me.

(Kimberly, 30)

Bodily-kinesthetic, spatial, and interpersonal were shown to be my dominant intelligences on the test. They all turned out to be true . . . it is the way I prefer to learn because I cannot sit still long enough to listen to a lecture in class.

(L'Tresea, 18)

I feel that my preferred intelligences are intrapersonal, spatial, and linguistic. I think this is evident in just about all of my activities in life and that most anyone who really knows me would agree with this. I have always learned better when able to see pictures of what it is I am doing instead of just having someone tell me what it is I am supposed to be doing. I work better alone than with others and I read voraciously, so the linguistic was nearly a given.

(Sonya, 18)

I learn by sharing through poems, collages, or music. Throughout the semester, I started to overcome being shy. I've always been able to express myself in writing, yet I learned by telling everyone what I got from the chapter instead of listening to the lecture. I became the teacher instead of the student.

(Jenny, 26)

I think the best ways for me to learn are through the intrapersonal and interpersonal approaches. I've always been perfectly capable of learning material and rewriting it on paper. However, it is only through personal reflection and interaction with other people, examining how they perceive the same material differently that gives me a better insight on how I learn. I'm very glad I was able to learn in a variety of ways. While I always really knew the best ways for me to

learn, few teachers have allowed me to reach those dimensions of my life.

(Darren, 29)

I feel bodily-kinesthetic is my strongest intelligence. I learn best by doing hands-on stuff such as building and touching things. Out of all the learning options, I enjoyed doing the collages the most. Another one of my preferred intelligences is spatial. I am a very visual learner. It really helps me to see things rather than just read them. It is for this reason I greatly enjoyed and maxed out on my video reviews.

(Bryan, 19)

On the multiple intelligences inventory used at the beginning of the course, I scored higher in musical and bodily-kinesthetic intelligences. This is pretty accurate . . . In my work and in my free time, I do a lot of activities which exercise these two intelligences . . . my two favorite hobbies are playing golf and playing the guitar.

(Angel, 40)

I loved to write poems, not just for the class, but outside as well. I have always written them, and it was great to be able to write one as well as get credit for the assignment that we were choosing to do.

(Kyle, 23)

The TIMI scores agree with my self-perception. The logical-mathematical intelligence indicates I should enjoy math and numbers, which I do. I also tend to work methodically and in sequence.

(Jacqueline, 28)

"No amount of skillful invention can replace the essential element of imagination."

—Edward Hopper

2. You were provided a variety of learning options for each chapter studied in the course. What specific learning options did you select and complete? Why did you select these? How did these options help you better understand the chapter(s)? Be specific and give examples. (100% of the students selected learning options which matched their preferred intelligences.)

I feel my preferred intelligence is visual/spatial. I was better able to remember the vocabulary and concepts by making chapter collages,

a painting, and a sculpture. The pictures served as mileposts for my memory.

(Bryan, 19)

I feel that I prefer learning linguistically and intrapersonally. I worked on projects such as a daily journal, the applied term paper, a poem, article reviews and any other project in which I could write papers and work alone.

(Stacy, 18)

My preferred learning style would have to be computer applications because of my logical-mathematical intelligence. What I learned from the computer applications seemed to stick with me the longest.

(Brent, 20)

For certain one of the most dominate intelligences I possess is linguistic, followed by intrapersonal in a close second. Every project I engaged in throughout the semester was something where I could sit at my computer and type out my thoughts and ideas.

(Jonathan, 20)

I feel that bodily-kinesthetic and visual/spatial were my dominant intelligences . . . I did a lot of collages. It helped me to see what I was learning. I was cutting and pasting, which shows that I need to *do* something.

(Michelle, 18)

I preferred the computer application because it was fun and gave me a new perspective on how I learn best.

(Catalina, 23)

I enjoyed the drawing most of all . . . I feel good when I draw, and I learn better too. I did a set of comics for part of a chapter on ego defense mechanisms. When I read about each mechanism in the book, I got a picture in my mind instantaneously of how to represent each in a humorous, but effective way.

(Michael, 18)

Both the computer applications and video reviews combined visual and informational techniques which I found extremely helpful.

(Ken, 22)

"Do not fear mistakes—there are none."

—Miles Davis

My selected style was the collage (visual/spatial and bodily-kines-thetic) . . . this gave me a way of working with my hands, cutting, pasting, moving things around. While my mind was busy thinking, my hands were busy too.

(Mary, 42)

At the beginning of the semester I did not know exactly what I was going to do, since the emphasis was not on paper and pencil tests. However, once I thought about it, I concluded that it was going to be an interesting and challenging semester and could provide me a great learning opportunity.

(Kara, 18)

I selected and completed the poetry, computer application, chapter collage and, for my final, I chose to do a painting. I chose these options because they were what interested me. They helped me to realize and build on all the different ways I am smart. These options helped by reinforcing the terms and concepts that I was learning from the book. It helped to bring dull and boring things to life with a little creativity.

(Dean, 20)

The poem was very challenging, but I chose to do it to see if I would be able to color out of the lines for a change. I'm so used to doing things the same. Whether it be note writing, studying, writing essays or reading, every year I use the same strategies. After coloring out of the lines, I found that I am able to comprehend things better if I do them in a different way.

(Antonio, 29)

The article reviews I focused on first because it was a reading/writ-ing summary kind of assignment. These I had been doing all my life and was accustomed to—they were in my "comfort zone." However, once we began sharing chapter collages and poems in class, I started to see how much of the same material (with the same definitions) could be connected and presented in creative, different ways!

(Sharleen, 22)

The very first and my favorite learning option that I selected was a collage. It was the most creative collage I have ever made because I was used to making the regular collages in grade school . . . The poems were pretty neat. At first I didn't like them, but they really challenged me, and now I have written two awesome poems.

(Allan, 28)

These options are effective in acting as supplementary instructor for the material in question. They win hands down over having to read from a book and answer a huge question and answer packet. The endless text also is extremely effective in inducing sleep. These options were a welcome change.

(Xela, 19)

. . . from this class I carry away a solid foundation, not only for future study of psychology, but application in my life.

(Steve, 38)

"I can teach you to dance, but you must hear your own music."

—Anonymous

Yes and no. Yes, because I really got involved in a few major topics. No, because the topics that I didn't like, I passed up and never really learned.

(Travis, 19)

I am prepared to take other psychology classes, because I not only learned Psychology 101, I lived it! I didn't memorize key terms in every chapter like some kind of robot, but I ingested the information—I took it in, related it to my own life, and made solid connections that will stay with me until long after my formal education is done.

(JoAnne, 25)

It (psychology) has come to where it fascinates me, and I am willing to move into another course.

(Mary, 27)

By actually doing the projects, I was able to learn the material . . . when I did the reading, research, and activities other than what was in the book, I was encouraged to think about what I was learning.

(Lloyd, 21)

In this class, I learned just as much material as in any other, but the difference was that the material learned will stay with me *longer*. For the other classes, I would have read the chapter, studied the key terms, crammed for the test and forgotten most of it by the next day. With this class, we had to apply what we learned, see it from different perspectives, and creatively put the terms not only in our own words but make our own connections with those words . . . And even though I didn't write a poem, just listening to all the ones shared in class forced me to reflect and make some real life connections of my own.

(George, 19)

This learning method encouraged me to think about starting a career in psychology because it gave me a taste of methods used in real research studies and helped me look inside of myself to question my inner feelings about my future goals. I think that for a method of teaching to go hit a student so hard to the point where the student becomes very enthusiastic about it and ponders the idea of wanting to become like his/her instructor, it has to be given a lot of credit and respect.

(Beverly, 36)

Not only do these learning options give students the chance to be creative, they also boost their self-esteem because everybody applauds at the end of the presentations.

(Cristina, 18)

"Take your life in your own hands and what happens? A terrible thing: no one to blame."

—Erica Jong

3. Do you feel reading/learning/doing and thinking about the course in this manner has provided an adequate foundation for taking other courses in this discipline? Why? Why not? Elaborate, be specific and give example. (98.5% of the students replied "yes"; 1.5% of the students replied "no".)

In taking this teaching approach and giving us learning options, you are putting the responsibility solely on us to learn the material to the best of our capability. We are the determining factor of our grade, not the instructor and the tests. I think students tend to learn more

when given the choice of learning or not. In allowing us to choose how we want to display the information learned, we ultimately spend quality time learning and not "cramming" and we will retain the information longer.

(Alejandro, 24)

I feel that I will have an advantage over other students in my upcoming psychology class because I was given the opportunity to learn in ways that will help me remember what psychology is about and the principles that apply. In fact, I will be disappointed if I am not given the chance to learn developmental psychology in this fashion, because I feel I am a multiple intelligences learner.

(Doug, 21)

I think the learning options did an exceptional job at preparing me for other psychology classes. Once again, it isn't as simple as knowing the information, that's the easy part. It's the ability to see beyond the walls that twelve years of public education and its expectations have laid down. This did a great job of preparing me . . . for every class. Even if the teacher doesn't care, I now know that I can go home and write a poem and learn from an entirely different perspective. The common misconception is that college students don't really want to learn; they just want their diplomas. Honestly, with my experiences, most students do want to learn. However, if they don't foresee that learning is useful, they will only learn what it takes to get by.

(Liesa, 22)

The different learning options took away a lot of the stress associated with learning.

(Bobby, 26)

I believe I learned more and retained more with the 'hands on' projects. If I had not had these options available in Psychology 101, I probably would have associated psychology with a lot of technical terms. I would not have realized how psychology envelops us in our daily transactions.

(Rebecca, 18)

I know I attained a basic knowledge, because for each chapter I have personal memories incorporated into the information.

(Nicole, 19)

The learning options reinforced the material in the text and quite often gave a wider perspective of the workings of psychology.

(Susan, 19)

... I expected this class to be *read, lecture,* and *test*. Instead, this class was totally motivating and stimulated a desire to learn more about psychology. I can directly apply it to my everyday functions with family and students.

(Cecilia, 46)

Because I spent time on my projects, I learned (and) reinforced the information studied in the text. I know Psychology 101 like the back of my hand, and I am confident that I can be just as successful in Psychology 240.

(Cristen, 19)

"The right angle to solve a difficult problem is the 'try-angle'."

—Ellis I. Levitt

No . . . because as you being the teacher, knowing well this subject, you probably could have given me more than what I tried to learn on my own.

(Mona, 27)

Yes, because this method of learning has helped me retain information better than the traditional classes.

(Daniel, 20)

... By learning psychology with this much depth, I have become fascinated with more areas of psychology.

(Paul, 19)

Yes . . . it has helped me gain an understanding of the concepts, because I not only had to work on the projects, but I also had to think and write about the projects.

(Stacy, 18)

I feel that taking this style of psychology course has prepared me better than a traditional course would have. This course let me explore myself and other areas of psychology because of the learning options. If I had only read the book, I would only know what the book wanted me to know. The learning options gave me the choice of exploring further into psychology than the book would allow.

(Tim, 20)

"The mind can only absorb what the seat can endure."

—Anonymous

4a. How has your motivation to learn the material from the course been affected by giving you options to select from? Be specific and give examples. (96.2% indicated the options *increased* their motivation to learn about psychology. 3.8% indicated the options *did not affect* their motivation to learn psychology.)

Having learning options that incorporate different types of intelligences is THE WAY TO GO! I am convinced. Since other classes do not offer this type of teaching (Lab is as close as it gets!), I will find my own way of incorporating these techniques into my learning regimen . . .

(Lucinda, 23)

In the beginning, I set out to obtain as many points as I possibly could in order to get an "A" in the class. As the semester went on, I found learning more fun, and I lost track of time and effort.

(Tracy, 27)

This was a great motivation for me because if I tried one thing and did not like the results, I did not have to try it again. I could try something else to see if another way was better.

(Joseph, 45)

I spent the entire semester engrossed in psychology. My motivation came in being able to choose. I was INTERESTED. Instead of waiting for stress to help me succeed, I was able to do work because I *wanted* to.

(Gina, 19)

I don't know if my interest in psychology has increased, as it has always been a keen interest of mine since I was a teenager. This fact didn't dawn on me until recently, when I noticed that a large part of my personal library—New Age, psychic phenomena, and ESP books— were all a part of psychology.

(Anna, 40)

By giving me learning options, I have been motivated to look deeper into psychology than just reading the book. The options gave me the choice to explore a particular part of psychology if I wanted to.

(Tim, 19)

By having different options, of which some will be more interesting to some people than others, I feel that retainment of something you learn that is interesting to you will stay with you longer than information that you are forced to learn . . .

(Robert, 24)

I feel I have had more motivation to learn about psychology because of the different learning options. The reason for this is because I was 'given' the chance to learn 'my' way. By being given this chance, I learned a lot more than if I were to have taken paper and pencil tests every week.

(Amy, 18)

My motivation to learn psychology has increased because I found it fascinating to learn in a different way.

(Rachel, 18)

I loved having options to select from. I felt more motivated because I was responsible for the amount of points that I received, as opposed to having set assignments with a certain amount of points possible. These learning options also allowed me to be creative with my work and to have the opportunity to learn in different ways.

(Stephanie, 18)

"Like an ability or a muscle, hearing your inner wisdom is strengthened by doing it."

—Robbie Gass

My motives for learning about psychology were not affected by being given options to choose from. My motivation has remained the same throughout the semester: to learn. I love to learn, and both your class and your teaching style were part of the reason I took the class.

(Jonathan, 20)

My motivation to learn about psychology has increased by having options to select from. It breaks up the standardized routine of regular school work and makes me want to do homework.

(Ken, 22)

I am confident enough to say that I am an excellent student and therefore can motivate myself to learn what I must to accomplish my goals, so the amount of motivation remains unchanged. However, the

quality of motivation is quite different after being given learning options. When faced with different learning options, I was forced to take many risks, and as a result, I learned a lot about myself. In the beginning, I was motivated to learn psychology, but in a very task-oriented manner. Now, I am challenged with learning psychology at a very personal level and incorporating many of my own ideas into the learning experience. The result is a much richer, more elaborate, more memorable learning experience.

<div align="right">(JoAnne, 27)</div>

I am more motivated because I am enjoying the way in which I am learning.

<div align="right">(Connie, 43)</div>

Yes, I was extremely motivated. I think, for the first time in all of my years in school, I was actually learning and comprehending. Comprehending everything made me want to know more and more.

<div align="right">(Denise, 23)</div>

By far, yes. I was able to learn in ways that helped me. By applying my work to my talents, I could be more successful.

<div align="right">(Paul, 22)</div>

I had the freedom to choose what was best for me. For me, being able to decide what I want to do is very motivating and a lot more interesting.

<div align="right">(Rachel, 20)</div>

I don't think it [options] affected my motivation much, because I selected the same options that would have been presented in a traditional classroom.

<div align="right">(Margaret, 19)</div>

Because you gave us options to choose from and allowed us a choice, I was not intimidated . . . I looked at the semester in a positive way—I looked forward to learning psychology the way I wanted to and receiving grades for what I chose to accomplish. MY CHOICE. Everyone becomes motivated when they have a *choice*.

<div align="right">(Cristen, 19)</div>

I was scared and a little confused for quite a while about the options. This method required some getting used to. However, when the first option was conquered, a door opened and psychology became more meaningful.

<div align="right">(Rebecca, 18)</div>

> *"Knowledge is the eye of desire and can become the pilot of the soul."*
>
> **—Will Durant**

My motivation to learn about psychology erupted when I saw the different learning options we had. I was given the chance to use and explore my creativity. I enjoy hands-on-learning tremendously. I love to draw, sculpt, and interact. In this setting, the students control their destiny. The students determine how deep they want to expand upon a certain concept. Once students are given a chance to step out of the standard options, they can conquer new options and gain the knowledge of not only psychology but also of themselves and their self-esteem. I think it's wonderful for both the students and the teacher. Each can see the other's progress throughout the semester. Teachers need that type of positive feedback in order to keep their zest and love of learning and teaching. Those qualities are important for students to see in the teacher, because it reassures the students and gets them interested in the subject.

(Kandi, 18)

My motivation to learn psychology was greatly increased by having the options that I did. I could finally learn my way. I actually found myself looking forward to doing school work. I must have something wrong with me, that's not supposed to happen. As I was going through the chapters reading new terms, pictures of things that reminded me of them would be popping into my head. I actually didn't dread doing the projects like I do in other classes.

(Albert, 26)

The weekly homework choices did help in my motivation. I suppose that instead of being pushed to finish for a grade (extrinsic motivation), I was also more interested in the subject matter we were studying and was excited to use my creativity to put into a chapter collage, poem, etc. (This would count as intrinsic motivation).

(Megan, 18)

I think that by having options to select from, my motivation to learn psychology grew a lot more than I really expected. At the beginning of the course it was a little bit difficult to make myself responsible for my own grade, but once I passed that stage, I started to have fun with the terms, the definitions, the concepts, and themes from the chapter.

(Joyce, 19)

My motivation has been affected because of the variety of learning options available and the grading structure where you control your final grade. This was a strong motivational tool for me. I have no one else to blame but myself for my chosen success or chosen failure. Very true to life in my opinion.

(Denise, 27)

"Ideas that aren't applied or tested tend to become anemic, and work that isn't examined and evaluated tends to become stale."

—Anonymous

For once I've been in charge of my grade. Throughout the course, I have always been able to know what my grade was for the class, and how to improve it. In other classes you are given a test over the material, and if you get a C you know what you have to do to raise it. Most of the time you can either study harder, but you really don't know if you comprehended the material. In this class I played the teacher, and I chose to get the grade I wanted. Yes, I was given options by the teacher, but I didn't necessarily have to do one I didn't like.

(Marge, 22)

Because of the fact that you let us decide what to do as homework and if we wanted to do anything at all, that gave me the motivation to complete tasks knowing that my grade was in my own hands. The options were fun and challenging which also gave me the motivation to do something different.

(Robin, 24)

One way motivation is generated is by offering choices to a person. If people have no options, they are then forced to act/respond/perform in a manner that is, in most cases, uncomfortable. Experiencing things out of a person's comfort zone is needed in order for a person to experience different life experiences. You motivate students by showing them respect, holding them accountable with clear expectations, and offering choices for results.

(Salvador, 40)

I think my motivation to learn about psychology was increased, because if I found a chapter boring or hard to understand, there were many other things I could do to help me better get the material. I don't think there would have been any motivation at all had it not

been for this method. I think the traditional lecture should be a choice. If we don't want to listen to it, then we shouldn't have to. It seems to make everyone fall asleep anyway, so what is the point?

(Lorena, 19)

People learn in different ways. Instead of believing the best way for everybody to learn is to read a book, you gave us other options. Those options forced me to think more deeply about the material and to get a little creative. The learning options allowed us to see how the material in the book related to real life.

(Tammy, 20)

My motivation has greatly been increased to learn psychology by being given learning options to choose from. Normally, I get so bored with classes and dread going to another "boring" class, but not this one. I actually looked forward to going to class and doing homework. I never thought I would say that. I had so much fun, and fun actually helped me to learn!

(Louie, 30)

I found it easier to be motivated about something we were not forced to do. For instance, I could not wait to get the final so I could draw my sketch. At first, I found it a little odd and difficult to choose which options to complete, but I did it and enjoyed them. The reason I found it odd was because no one has ever challenged me to be responsible for my own actions and to choose homework to finish. They just assumed that I would be responsible.

(Rose, 18)

The learning options affected my motivation in that I knew right away that I was going to learn from this course. Because there were several choices of ways to learn the material, I could see that the goal of the course was learning, no matter how the learning occurred.

(Rachel, 24)

"Creativity is harnessing universality making it flow through your eyes."

—Peter Koestenbaum

4b. How much time did you spend studying/doing/or thinking about the course outside of class? (Circle one).

1. 03-06 hours weekly
2. 06-10 hours weekly
3. 10-15 hours weekly
4. 15-20 hours weekly
5. 20+ hours weekly

In addition to asking this question to the students in the pilot study, 125 students taking general education courses at GCC were randomly selected and asked the same question with following results:

Pilot Study Classes	*General GCC Classes*
11.4 average hours/week	5.6 average hours/week
(131 students surveyed)	(125 students surveyed)

4c. What was your motivation for spending this amount of time learning and applying the material covered in your textbook or in class? Be specific and give examples.

I took a more opened-minded perspective with the course from the beginning, because we were allowed to explore the material in different ways. Just the fact that we had *choices* in the matter made me work more than anything else.

(Erik, 18)

I didn't want to spend too much time since "I do just enough to get by;" however, the class discussions motivated me to read the chapter through once, then study it the hour before psychology, while I was waiting for my friend to get out of math, so that I could hopefully understand what was going on in class.

(Jason, 22)

Like I stated earlier, my motivation was FUNNESS. (I don't think that is a word . . . but it should be). I couldn't wait to get home and start one of my new learning options. Also, my motivation was challenge. I love a challenge, and when you challenged us, I was excited.

(Elna, 24)

My motivation for spending this amount of time learning about the material covered in the textbook was the fact that I could choose to do what would benefit me the most. There was no pressure to learn in any one way. I enjoyed having the variety.

(Donna, 25)

"You have to know that your real home is within."

—Quincy Jones

When asked why they spent this amount of time on the course, the students in the pilot study (131) and the students taking general education courses (125) responded:

Pilot Study	**General Classes**
"I spent more time because I *enjoyed* learning."	"I *worried* about the class _____ hours per week."

5a. In what other college classes could an MI / LfU approach be effectively used?

Rank Order	**Other Classes**
1	"Any" College Class
2	Biology, English
3	History
4	"Any" Science Class
5	Math
6	Chemistry, Nursing, Sociology
7	Speech Communication
8	Physics, Humanities, Business
9	Anthropology, Child/Family Studies, Foreign Languages
10	Art, Computer Science, Education, Philosophy, Physical Science

"The individuality of minds and the fact that we cannot possibly master everything are the strongest arguments against a uniform school system and for learner-centered schools where, in a nutshell, we treat individual differences differently."

—Howard Gardner, "Nature of Intelligence," 1991

5b. How might this approach be utilized in other courses? Give examples.

Some classes here (and some other schools) are just not geared for everyone. If the MI approach was offered, people could adjust their learning appropriately.

(Bobby, 18)

Yes, multiple intelligence projects could be incorporated into almost any class that has a teacher and students with open minds.

(Steve, 23)

MI can be used in anything, for we use all our intelligences no matter where we are and what we are doing . . . the options you gave us are applicable to any material.

(Sonja, 19)

I strongly feel that the MI approach could be used for other classes. I feel the approach kept students interested and helped them learn the best way they knew how . . . the MI approach gave me a chance to feel good about myself and feel I could learn and be smart.

(Melisa, 24)

Yes, in biology, sociology, history, and government classes. By giving people choices (with) learning options, they may learn more, because you keep their interest.

(Tammy, 24)

An MI approach could be utilized in any college class from American history to zoology, and in my opinion, all classes would benefit. I think doing visual representations (collages) would make information more personally real and more memorable (particularly if it is your personal visual interpretation). Having choices to view videos or read articles and books that expand on class material are not only good ways to understand the material, but [they] stimulate interest by giving students a choice . . .

(Willard, 39)

For almost any class or subject matter, some form of MI could be used to help students better understand, and hopefully learn, the material. For history, a sculpture on a group of people or the effects of a battle could be done . . . or an interview could be arranged with an important military or government leader.

(Doug, 44)

I believe that this particular type of learning program can be used in almost any class in college . . . and I believe it could help many students stick with school and not drop out.

(Brian, 18)

I think that the MI approach could be utilized in other types of college classes. I think it could be used in any of the science classes, also in history and humanities. I think that doing the learning options made learning more fun. It made me remember the things that I am being taught, instead of just remembering facts for a test and then forgetting them after the test is over.

(Kandi, 19)

Can this approach be applied to another class? It depends on the teacher. If the teacher is willing to include it into his/her agenda, then yes. However, some teachers are inherently boring, and the answer is no for them.

(Toni, 26)

"Take a chance! All life is a chance. The person who goes farthest is generally the one who is willing to dare."

—Dale Carnegie

I think that an MI approach should be used in other classes. I cannot think of one curriculum that couldn't benefit from learning this way. By having different learning options, it could take some of the pressure off of students that are uncomfortable in some classes.

(Carline, 19)

I think that the multiple intelligences approach could very well be used in other college classes. I think the collages can be used for any class. I think sculptures would be great to do in science classes like biology or chemistry.

(Michele, 20)

The MI approach can be a very valuable tool in ANY OTHER AND ALL OTHER CLASSES. I used a collage in Biology 105 to show a food web, and it was the best thing I could have done for myself. I am sure it is something that will stay with me for a long, long time . . . I am here to LEARN, not just to get a degree and move on. This [MI] also makes school fun!

(Debbie, 46)

I think an MI approach could be utilized in all classes. I think it should be because everyone learns in different ways. By giving them options, it allows them to learn in a way that they are more able and willing to learn.

(Michelle, 19)

An MI approach could definitely be used in other classes. Communications classes, for example, could use collages. What better way to get comfortable speaking in front of a group than to get up and explain something that you did, something that means something to you.

(Justin, 18)

I would advocate using the MI approach in every subject! I could have really used this approach in my Chemistry 151 class. For example, you could do a collage of the periodic table with different types of metals and nonmetals . . . there are endless possibilities for students to do collages, drawings and sculptures in any subject. It is up to the teacher to provide the tools we need to unlock the mind's endless capacity.

(Jennifer, 18)

I think the MI approach is a wonderful way to learn in all subjects. There is so much possibility for this type of learning. It celebrates and appreciates all skills. The world must be introduced to this!

(Gretchen, 19)

An MI approach would be very beneficial in many different courses. I could definitely see collages, paintings and poems being used in history, English, communications, art, and science. By taking a nontraditional approach to learning, excitement to learn is created. By having choices, you feel empowered and are more likely to do your best job, and you will retain more information. By having options, you can dig deeper and not just memorize something to get through the class.

(Kimberly, 30)

"Learning is like rowing up stream, not to advance is to drop back."
—Chinese Proverb

I definitely think the MI approach could be utilized in other classes. The collage would be great help when you are having difficulty understanding material in a class like science or something. That kind of material is hard to grasp, but if you take a different approach rather than just the book/test, it would be grasped more easily. I also think the poetry aspect would help in this subject. People need to learn that learning can be fun!

(Christine, 19)

I think MI can be used in almost all types of college classes. Math, for instance. Instead of just reading the chapter and taking tests, I think students would learn more if there were other options . . . I think the classes that this would be best in are the ones you have to take for a degree. It would be especially great in those boring lecture classes!

(Chloe, 23)

Definitely. I believe an MI approach probably could be utilized in any college class, although I don't believe that will ever happen. You are still learning the material, you're only doing it in a different way—a better way if you ask me. I get through so many classes by cramming the night before a test, I don't learn much, but it gets me an "A" in the class. In this class I actually learned something. It was a little more work, but as much as I hate to admit it, I enjoyed it . . . The poem took me all weekend to write, but it felt great when it was done. I will never forget it. Thank you for challenging me to try something different. I had a BLAST!!!

(Willie, 26)

"Nature forms us for ourselves, not for others, to be, not to seem."

—Michel de Montaigne

Having traditional closed-book pen/pencil/paper tests as a sole evaluation of a person's abilities to succeed doesn't work; all it does is test a student's memory. In real life and in real work place conditions, reliance on memory is not done. Learning something usually comes by doing something. For example, in chemistry and math we have to memorize complicated formulas. In real life, these are done by computers or by using notes. Being able to put these formulas into practice is what should be important, not memorizing them. I found I actually worked harder with the learning options than if I had just done the reading, memorized the names and concepts, and gave it back at test time.

(Jackson, 33)

This approach could be used in all science classes as well as history classes. Picking out key terms and concepts and exploring them in depth was very helpful. If we would have not used the MI approach, I guarantee that I would not understand much of what was covered, nor would I have most likely cared to.

(Joe, 44)

Students Want Different Learning Options!

MI /LfU Pilot Study (1994-96)

Psychology 101

Students Will Take Risks IF They Are Invited To!

CHAPTER SEVEN

Afterthought: Reach for the Paint Brushes & Crayons!

I began this book by telling the story of Javier, how he *demonstrated* personal understanding of the brain's functions. He did this in spite of a system that did not offer him any outlet to use his creativity and imagination in applying, in ways that make sense to him, what I was trying to teach him. I take full responsibility for being part of the problem. I believe there are many Javiers falling through the cracks. Look around. Maybe they are your son, daughter, husband, wife, people you work with, friends, or even *you* who may fall into this dilemma because learning in a way, a *different* way that makes sense to you is not recognized, rewarded, or accepted as *real* learning.

"May you never arrive in the process of 'becoming' the man you want to be."

—Rudy J. Melone

Writing this book has been a pleasurable experience. I have learned a great deal about writing. My intent was to write in an emotional, not a literal sense. I attempted to touch readers' *feelings*. Writing demands revelation. There are risks in exposing oneself and one's ideas. I accepted this notion once I made the decision to publish. After all, the root of the term publication comes from *public*. If I have challenged people to think about what learning is and how we are *all* capable of learning, whether in a "formal" environment like high school or college, a training course offered in business and industry, or in *everyday* life, I have accomplished what I set out to do.

CHAPTER 11: INTELLIGENCE

Judge me not solely on a written test.
That day I may not have been at my best.
Judge me rather by a certain deed
that provides a service for those in need.

Learning only from scribed or spoken word
could seem to many a method absurd.
This method of learning may work for most;
but for some it doesn't - and at what cost?

Some feel quite at home with products and sums;
yet some learn by beating different drums.
Musically inclined understand a beat -
erudition in song an easy feat.

For some colors, textures and shapes are good;
or carving things of clay, marble or wood.
And other folks express themselves with dance,
or require movement to give them a chance.

Many need people to help them along -
learning WITH others can make them feel strong.
Or, figuring things out yourself is great,
seeking answers alone to postulate.

Like a colorful spectrum of wonder
It'll be for each of us to ponder
if each type of smart were red green or blue
matched up like our minds, what color are you?

GO FOR IT!

I encourage you to utilize anything in this book that will enhance the learning process and spark the creativity and imagination of *both* teacher/trainer and learner. It works for me; I hope it works for you.

I believe the theory of multiple intelligences is one of today's most exciting areas of study and real-life application in the field of psychology. This book was written to be utilized and applied. I welcome comments, thoughts, and feelings on the application of the multiple intelligences/learning for understanding format presented in this book.

Send comments and correspondence to:

René Díaz-Lefebvre, Ph.D.
Glendale Community College
6000 West Olive Avenue
Glendale, Arizona 85302

email: díaz@gc.maricopa.edu

If learners are provided choices and options in applying *how* they are smart, their motivation and desire to authentically learn will go *beyond* learner and teacher expectations. Grab your crayons and brushes; start coloring!

"I speak the truth not because I should, but because I must. And the older I get the more I must."

—Michel de Montaigne

Suggested Readings

Adams, J. L. (1986). *The care and feeding of ideas: A guide to encouraging creativity*. Reading, MA: Addison-Wesley Publishing Company.

Amabile, T. M. (1979). Effects of external evaluation on artistic creativity. *Journal of Personality and Social Psychology*, 33, 221–33.

Amabile, T. M. (1982). Social psychology of creativity: A consensual assessment technique. *Journal of Personality and Social Psychology*, 43(5), 997–1013.

Amabile, T. M. (1985). Motivation and creativity: Effects of motivational orientation on creative writers. *Journal of Personality and Social Psychology*, 48, 393–99.

Anastasi, A., and Schaefer, C. E. (1971). Note on the concepts of creativity and intelligence. *Journal of Creative Behavior*, 5, 113–116.

Armstrong, T. (1991). *Awakening your child's natural genius: Enhancing curiosity, creativity, and learning ability*. New York: Putnam Publishing Group.

Armstrong, T. (1993). *7 Kinds of smart: Identifying and developing your many intelligences*. New York: Plume, Penguin Group.

Barron, F. (1963). *Creativity and psychological health*. New York: Van Nostrand.

Barron, F. (1969). *Creative person and creative process*. New York: Holt, Rinehart, and Winston.

Bellanca, J., Chapman, C., and Swartz, E. (1994). *Multiple assessments for the multiple intelligences*. Palatine, IL: IRI/Skylight Publishing.

Bloomberg, M. (1973). *Creativity: Theory and research*. New Haven, CT: College & University Press.

Blythe, T. (1998). *The teaching for understanding guide*. San Francisco: Jossey-Bass.

Blythe, T., and Gardner, H. (1990). A school for all intelligences. *Educational Leadership*, 47(7), 33–37.

Boneau, C. A. (1990). Psychological literacy. *American Psychologist*, 45, 891–900.

Brown, R. T. (1989). Creativity: What are we to measure? In J. A. Glover, R. R. Ronning, and C. R. Reynolds (Eds.), *Handbook of creativity* (pp. 3–32). New York: Plenum Press.

Bruner, J. S. (1973). *Beyond the information given: Studies in the psychology of knowing*. New York: Norton.

Caine, R. N., and Caine, G. (1993). Brain research: Perspectives on the promise and perils of learning in cooperative groups. *Cooperative Learning*, 13(2), 24–25.

Caine, R. N., and Caine, G. (1993). Understanding a brain-based approach to learning and teaching. *Educational Leadership*, 48(2), 66–70.

Caine, R. N., and Caine G. (1994). *Making connections: Teaching and the human brain.* New York: Addison Wesley Innovation Learning Publication.

Calhoun, H. D. (1991). Implementing institutional effectiveness at two-year colleges. In J. O. Nichols (Ed.), *A practitioner's handbook for institutional effectiveness and student outcomes assessment implementation.* New York: Agathon Press.

Case, R. (1992). *The mind's staircase: Exploring the conceptual underpinnings of children's thought and knowledge.* Hillsdale, NJ: Erlbaum.

Chapman, C. (1993). *If the shoe fits: How to develop multiple intelligences in the classroom.* Palatine, IL: IRI/Skylight Publishing.

Cochran-Smith, M., and Lytle, S. L. (1993). *Inside/outside: Teacher research and knowledge.* New York: Teachers' College Press.

Cohen, D. K., McLaughlin, M. W., and Talbert, J. E. (Eds.). (1993). *Teaching for understanding: Challenges for policy and practice.* San Francisco: Jossey-Bass.

Costa, A., Bellanca, J., and Fogarty, R. (1993). *If minds matter: A foreword to the future.* Vol. 2. Palatine, IL: IRI/Skylight Publishing.

Csikszentmihalyi, M. (1988). Society, culture, and person: A systems view of creativity. In R. J. Sternberg (Ed.), *The nature of creativity* (pp. 325–39). New York: Cambridge University Press.

Csikszentmihalyi, M. (1991). *Flow: The psychology of optimal experience.* New York: Harper Perennial.

Cuban, L. (1993). *How teachers taught: Constancy and change in American classrooms, 1890–1980.* New York: Teachers' College Press.

Davidson, L. (1990). Tools and environments for musical creativity. *Music Educators Journal,* 76(9), 47–51.

Davidson, L., and Torff, B. (1993). Musical intelligence. In R. Sternberg and S. Ceci (Eds.), *Encyclopedia of intelligence.* New York: Macmillan.

Dewey, J. (1959). *Experience and education.* New York: Macmillan.

Diamond, M. (1988). *Enriching heredity: The impact of the environment on the anatomy of the brain.* New York: Free Press.

Díaz-Lefebvre, R. (April, 1997). Unlocking the motivation, the desire, and the joy to learn! *Innovation Abstracts,* 19, 12.

Díaz-Lefebvre, R., (1998). I can never go back. *The Forum,* 6, 2. Spring: 3–4.

Díaz-Lefebvre, R., and Finnegan, P. (1997). Coloring outside the lines: Applying the theory of multiple intelligences to the community college setting. *Community College Journal,* 68(2): 28–31.

Díaz-Lefebvre, R., Siefer, N., and Pollack, T. (1998). What if they learn differently: Applying multiple intelligences theory in the community college. *Leadership Abstracts,* 11, 1.

Dorman, G., and Lipsitz, J. (1984). Early adolescent development. In G. Dorman (Ed.), *Middle Grades Assessment Program*. Carrboro, NC: Center for Early Adolescence.

Dreistadt, R. (1974). The psychology of creativity: How Einstein discovered the theory of relativity. *Psychology, 11,* 15–25.

Dryden, G., and Vos, J. (1994). *The learning revolution.* Rolling Hills Estates, CA: Jalmar Press.

Dweck, C. (1986). Motivational processes affecting learning. *American Psychologist, 41,* 1040–1048.

Dweck, C., and Elliot, E. S. (1983). Achievement motivation. In E. M. Hetherington (Ed.), *Socialization, personality, and social development.* New York: Wiley.

Elias, M. J., Bruene-Butler, L., Blum, L., and Schuyler, T. (1997). How to launch a social and emotional learning program. *Educational Leadership, 54*(8), 15–19.

Entwistle, A. C., and Entwistle, N. J (1992). Experiences of understanding in revising for degree examinations. *Learning and Instruction, 2,* 1–22.

Entwistle, N. J., and Entwistle, A. C. (1991). Contrasting forms of understanding for degree examinations: The student experience and its implications. *Higher Education, 22,* 205–227.

Entwistle, N. J., and Marton, F. (1994). Knowledge objects: Understandings constituted through intensive academic study. *British Journal of Educational Psychology, 64,* 161–178.

Feldman, D. H., Csikszentmihalyi, M., and Gardner, H. (1994). *Changing the world: A framework for the study of creativity.* Westport, CT: Greenwood Publishing Company.

Fetterman, D. M. (Ed.). (1991). Using qualitative methods in institutional research. *New Directions for Institutional Research,* No. 72. San Francisco: Jossey-Bass.

Fullan, M. G. (1991). *The new meaning of educational change.* New York: Teachers' College Press.

Fullan, M. G. (1993). *Change forces: Probing the depths of educational reform.* Bristol, PA: Falmer Press.

Gardner, H. (1979). Developmental psychology after Piaget: An approach in terms of symbolization. *Human Development, 22,* 73–88.

Gardner, H. (1983). *Frames of mind.* New York: Basic Books.

Gardner, H. (1984). Assessing intelligences: A comment on testing intelligence without I.Q. tests. *Phi Delta Kappan,* June, 699–700.

Gardner, H. (1991). Assessment in context: The alternative to standardized testing. In B. Gifford and M. C. O'Connor (Eds.), *Changing assessments: Alternative views of aptitude, achievement, and instruction* (pp. 239–252). Boston: Kluwer Publishers.

Gardner, H. (1991). *The unschooled mind: How children think and how schools should teach.* New York: Basic Books.

Gardner, H. (1993). *Creating minds.* New York: Basic Books.

Gardner, H. (1993). *Multiple intelligences: The theory in practice.* New York: Basic Books.

Gardner, H., and Mansilla, V. Boix (1994). Teaching for understanding in the disciplines and beyond. *Teachers' College Record,* 96(2), 198–218.

Gardner, H. (1995). Reflections on multiple intelligences: Myths and messages. *Phi Delta Kappan,* 77(3), 200–209.

Goleman, D. (1995). *Emotional intelligence.* New York: Bantam.

Gowan, J. C. (1972). *Development of the creative individual.* San Diego: Robert R. Knapp.

Gray, C. E. (1966). A measurement of creativity in western civilization. *American Anthropologist,* 68, 1384–1417.

Greenberg, M. T., and Snell, J. (1997). The neurological basis of emotional development. In P. Salovey and D. Sluyter (Eds.), *Emotional development and emotional intelligence: Implications for educators.* New York: Basic Books.

Grossman, P. L., and Stodolsky, S. S. (1995). Content as context: The role of school subjects in secondary school teaching. *Educational Researcher,* 24, 5–11, 23.

Guilford, J. P. (1950). Creativity. *American Psychologist,* 5, 444–54.

Guilford, J. P. (1967). *The nature of human intelligence.* New York: McGraw-Hill.

Guskey, T. R., and Huberman, M. (Eds.). (1995). *Professional development in education: New paradigms and practices.* New York: Teachers' College Press.

Haensly, P. A., and Reynolds, C. R. (1989). Creativity and intelligence. In J. A. Glover, R. R. Ronning, and C. R. Reynolds (Eds.), *Handbook of creativity* (pp. 111–32). New York: Plenum Press.

Haggerty, B. A. (1995). *Nurturing intelligences: A guide to multiple intelligences theory and teaching.* Menlo Park, CA: Innovative Learning, Addison-Wesley Publishing Company.

Hanshumacher, J. (1980). The effects of arts education on intellectual and social development: A review of selected research. *Bulletin of the Council for Research in Music Education,* 61(2), 10–28.

Hart, L. (1975). *How the brain works: A new understanding of human learning, emotion, and thinking.* New York: Basic Books.

Hooper, J., and Teresi, D. (1986). *The three-pound universe: The brain, from chemistry of mind to new frontiers of the soul.* New York: Dell.

Kline, P. (1988). *The everyday genius: Restoring children's natural joy of learning—and yours too.* Arlington, VA: Great Ocean Publishers.

Kornhaber, M., Krechevsky, M., and Gardner, H. (1991). Engaging intelligences. *Educational Psychologist*, 25 (3 and 4), 177–199.

Landrum, G. N. (1993). *Profiles of genius: Thirteen creative men who changed the world*. Buffalo, NY: Prometheus Books.

Lazear, D. (1994). *Multiple intelligence approaches to assessment: Solving the assessment conundrum*. Tucson, AZ: Zephyr Press.

Lightfoot, S. L. (1993). *The good high school*. New York: Harper Collins.

MacGregor, J. (Ed.). (1993). Student self-evaluation: Fostering reflective learning. *New Directions for Teaching and Learning*, No. 56 (Winter), San Francisco: Jossey-Bass.

Maddi, S. R. (1965). Motivational aspects of creativity. *Journal of Personality*, 33, 330–47.

Majoy, P. (1993). *Doorways to learning: A model for developing the brain's full potential*. Tucson, AZ: Zephyr Press.

Marks-Tarlow, T. (1995). *Creativity inside out: Learning through multiple intelligences*. Menlo Park, CA: Addison-Wesley Publishing Company.

Marton, F., and Saljo, R. (1976). On qualitative differences in learning I: Outcome and process. *British Journal of Educational Psychology*, 46, 4–11.

Marton, F., and Saljo, R. (1984). Approaches to learning. In F. Marton, D. J. Hounsell, and N. J. Entwistle (Eds.), *The experience of learning*. Edinburgh: Scottish Academic Press.

Maslow, A. H. (1959). Creativity in self-actualizing people. In H. H. Anderson (Ed.), *Creativity and its cultivation*. New York: Harper and Brothers.

Maslow, A. H. (1972). A holistic approach to creativity. In C. W. Taylor (Ed.), *Climate for creativity* (pp. 287–293). New York: Pergamon Press.

May, R. (1975). *The courage to create*. New York: Norton.

Mayer, J., and Salovey, P. (1995). Emotional intelligence and the construction and regulation of feelings. *Applied and Preventive Psychology*, 4(2), 197–208.

Mayer, R. E. (1989). Models for understanding. *Review of Educational Research*, 59, 43–64.

McKeough, A., Lupart, J., and Marini, A. (Eds.). (1995). *Teaching for transfer: Fostering generalization in learning*. Hillsdale, NJ: Erlbaum.

McLaughlin, M. W., and Oberman, I. (Eds.). (1996). *Teacher learning: New policies, new practices*. New York: Teachers' College Press.

Meier, D. (1995). *The power of their ideas*. Boston: Beacon Press.

O'Banion, T. (1997). *A learning college for the 21st century*. Phoenix, AZ: Oryx Press.

Ochse, R. (1990). *Before the gates of excellence: The determinants of creative genius.* New York: Cambridge University Press.

O'Connor, A. T., and Callahan-Young, S. (1994). *Seven windows to a child's world: 100 Ideas for the multiple intelligences classroom.* Palatine, IL: IRI/Skylight Publishing.

Ornstein, R., and Sobel, D. (1987). *The healing brain: Breakthrough discoveries about how the brain keeps us healthy.* New York: Simon and Schuster.

Osborn, A. F. (1963). *Applied imagination* (3rd ed.). New York: Charles Scribner & Sons.

Palmer, P. J. (1998). *The courage to teach: Exploring the inner landscape of a teacher's life.* San Francisco: Jossey-Bass.

Perkins, D. (1992). *Smart schools: From training memories to educating minds.* New York: Free Press.

Perkins, D. (1995). *Outsmarting IQ: The emerging science of learnable intelligence.* New York: Free Press.

Perkins, D., and Blythe, T. (1994). Putting understanding up front. *Educational Leadership*, 51(5), 4–7.

Perrone, V. (1994). Teaching for understanding in the classroom. *Educational Leadership*, 51(5), 11–13.

Pintrich, P. R., Marx, R. W., and Boyle, R. A. (1993). Beyond cold conceptual change: The role of motivational beliefs and classroom contextual factors in the process of conceptual change. *Review of Educational Research*, 63(2), 167–200.

Rogers, C. R. (1976). Toward a theory of creativity. In A. Rothenberg and C. R. Hausman (Eds.), *The creativity question* (pp. 296–305). Durham, NC: Duke University Press. (Originally published in 1954.)

Rosner, S., and Abt, L. E. (Eds.). (1970). *The creative experience.* New York: Grossman Publishers.

Sarnoff, D. P., and Cole, H. P. (1983). Creativity and personal growth. *Journal of Creative Behavior*, 17, 95–102.

Senge, P. M. (1990). *The fifth discipline: The art and practice of the learning organization.* New York: Doubleday.

Scherer, M. (1985). How many ways is a child intelligent? *Instructor*, January, p. 32–35.

Schön, D. A. (1983). *The reflective practitioner.* New York: Basic Books.

Schön, D. A. (1990). *Educating the reflective practitioner.* San Francisco: Jossey-Bass.

Schwartz, J. L., and Viator, K. (Eds.). (September, 1990).*The prices of secrecy: The social, intellectual, and psychological costs of current assessment practices.* Report to the Ford Foundation. Cambridge, MA: Educational Technology Center, Harvard Graduate School of Education.

Shearer, C. B. (1996). *The MIDAS: Multiple intelligence developmental assessment scale.* Columbus, OH: Greyden Press.

Shulman, L. S. (1986). Those who understand: Knowledge growth in teaching. *Educational Researcher, 15*(2), 4–14.

Shulman, L. S. (1987). Knowledge and teaching: Foundations of the new reform. *Harvard Educational Review, 57,* 1–22.

Simmons, R. (1994). The horse before the cart: Assessing for understanding. *Educational Leadership, 51*(5), 22–23.

Sizer, T. R. (1984). *Horace's compromise: The dilemma of the American high school.* Boston: Houghton Mifflin.

Sternberg, R. J. (1985). *Beyond IQ: A triarchic theory of human intelligence.* New York: Cambridge University Press.

Sternberg, R. J. (1985). Implicit theories of intelligence, creativity, and wisdom. *Journal of Personality and Social Psychology, 49,* 607–27.

Sternberg, R. J. (1988). *The triarchic mind: A new theory of human intelligence.* New York: Viking Penguin.

Sternberg, R. J. (Ed.). (1988). *The nature of creativity: Contemporary psychological perspectives.* New York: Cambridge University Press.

Sternberg, R. J. (1988). A three-facet theory of creativity. In R. J. Sternberg (Ed.), *The Nature of Creativity* (pp. 125–47). New York: Cambridge University Press.

Sternberg, R. J. (1990). *Metaphors of mind: Conceptions of the nature of intelligence.* New York: Cambridge University Press.

Sternberg, R. J. (1996). *Successful intelligence: How practical and creative intelligence determines success in life.* New York: Simon and Schuster.

Sternberg, R. J. (1997). Introduction to the special issue on intelligence and lifelong learning. *American Psychologist, 52*(10), 1030–1037.

Sternberg, R., and Delterman, D. (1986). *What is intelligence? Contemporary view points on its nature and definition.* New Jersey: Ablex Publishing Corp.

Sternberg, R. J., and Lubart, T. I. (1995). *Defying the crowd: Cultivating creativity in a culture of conformity.* New York: Free Press.

Stodolsky, S. S. (1988). *The subject matters: Classroom activity in math and social studies.* Chicago: University of Chicago Press.

Svensson, L. (1984). Skill in learning. In F. Marton, D. J. Hounsell, and N. J. Entwistle (Eds.), *The experience of learning.* Edinburgh: Scottish Academic Press.

Teele, S. (1992). *The role of multiple intelligences in the instructional process.* Redlands, CA: Sue Teele and Associates (University of California, Riverside).

Teele, S. (1992). *Teaching and assessment strategies appropriate for the multiple intelligences.* Redlands, CA: Sue Teele and Associates (University of California, Riverside).

Teele, S. (1992). *Teele inventory of multiple intelligences.* Redlands, CA: Sue Teele and Associates (University of California, Riverside).

Teele, S. (1995). *The multiple intelligences school—a place for all students to succeed.* Redlands, CA: Sue Teele and Associates. (University of California, Riverside).

Tishman, S., Perkins, D., and Jay, E. (1995). *The thinking classroom: Learning and teaching in a culture of thinking.* Needham Heights, MA: Allyn & Bacon.

Tobias, S. (1994). Interest, prior knowledge, and learning. *Review of Educational Research, 64,* 37–55.

Tyack, D., and Cuban, L. (1995). *Tinkering toward utopia: A century of public school reform.* Cambridge, MA: Harvard University Press.

Wagner, R. K., and Sternberg, R. J. (1986). Tacit knowledge and intelligence in the everyday world. In R. J. Sternberg and R. K. Wagner (Eds.), *Practical intelligence: Nature and origins of competence in the everyday world* (pp. 51–83). New York: Cambridge University Press.

Walters, J., Seidel, S., and Gardner, H. (1994). Children as reflective practitioners: Bringing metacognition to the classroom. In C. Collins-Block and J. Mangieri (Eds.), *Creating powerful thinking in teachers and students: Diverse perspectives.* Fort Worth: Harcourt Brace.

Webster's Ninth New Collegiate Dictionary. (1983). Springfield, MA: Merriam-Webster.

Whitehead, A. N. (1929). *The aims of education and other essays.* Old Tappan, NJ: Macmillan.

Wiske, M. S. (Ed.). (1998). *Teaching for understanding: Linking research with practice.* San Francisco: Jossey-Bass.